Cover: View of Teignmouth from the south; photograph courtesy Peter Doel
Overleaf: Map of Dawlish including East Teignmouth, 1044 AD.
Title Page: Teignmouth and Shaldon from Wear Farm Caravan Park

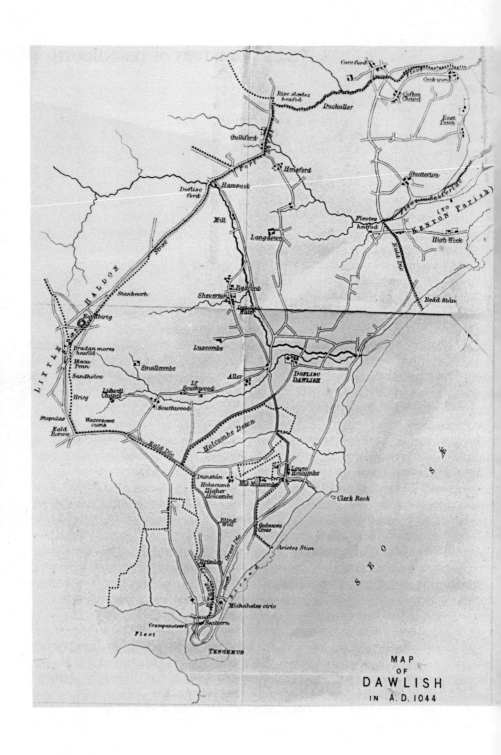

MAP
OF
DAWLISH
IN A.D. 1044

HISTORY OF TEIGNMOUTH

Grace Griffiths

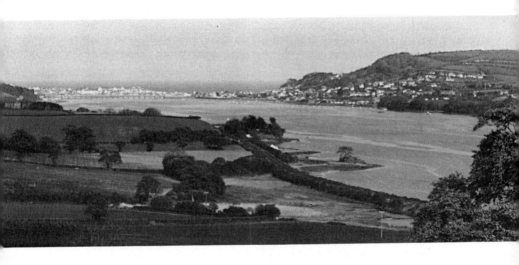

Photography by Michael Sabel

EX LIBRIS PRESS

First published in 1965
New edition 1973
This revised, expanded and newly illustrated edition published 1989 by
Ex Libris Press
1 The Shambles
Bradford on Avon
Wiltshire

Cover by 46 Design, Bradford on Avon
Typeset in 10 on 12 point Plantin by
Saxon Printing Ltd., Derby
Printed in Great Britain by BPCC Wheatons Ltd., Exeter

ISBN 0 948578 17 3

CONTENTS

ACKNOWLEDGEMENTS

The author wishes to thank the many friends who contributed to this book. She is especially grateful to the late Mrs H Mardon for permission to use Mr Mardon's translations of early documents, to Mr John Reed, whose knowledge of West Teignmouth parish is boundless, to Mr and Mrs John F Hook and other members of the Hook family, to Mr Harry Sealey, Mrs D Millican, Mr R Pope, Mr E Chapman, Mr D Leggatt, the late Mr W Hayman, Teignmouth Historical and Museum Society and Devon Library Services. With so much help the book almost wrote itself.

INTRODUCTION

I came to Teignmouth in 1946, from mid-Devon. At that time I was not interested in local history, or indeed, in history of any kind. It was a local fisherman, Dennis Dodd, whose stories about what the French did to Teignmouth, and 'they old barons' which fascinated me. Den had never forgiven the French – 'never trust them Froggies, maid' – they had burned his town. The Spanish he could stomach – just – after all they had only threatened the whole of England, but with the French it was a personal matter.

I soon discovered that Den's time scale was vastly inaccurate. Events of which he spoke as happening yesterday, happened hundreds of years ago. But no matter. I began to delve into the history of Teignmouth – the history of the people of Teignmouth – to whom I dedicate this book.

Grace Griffiths
Teignmouth
May 1989

1 THE EARLIEST TIMES

Countless ages ago the earth threw up the molten rock which was to become Dartmoor, the backbone of the County of Devon. For a while the great rock mass was part of the continent which we now call Europe, and the West Country was linked to France. Movements continued intermittently over thousands of years, the waters filled the depression which was to become the English Channel, cutting off Britain from the rest of Europe and making islands of the continental hills. Traces of eleven separate beaches can still be found on Haldon.

Ice ages came and went, and although they did not reach as far south as Dartmoor, snowslips which preceded the glaciers carried rock debris (known locally as clitters) which was scattered beneath rocky outcrops. In the warmer intervals between the centuries of ice great floods of rain weathered and split the rock plateau and swept from the highland in steep, stormy torrents, carving for themselves deep, narrow channels which were to become the rivers Taw, Torridge, Plym, Dart and Teign. The last carried with it thousands of tons of felspar fragments, washed out of the granite which had been rotted by the acidity of the rainwater; this was deposited as sediment in a lake which filled the Bovey basin and was later compacted to form ball clay. The Teign cuts through the softer rocks below the moor and pours into the sea through a sunken valley – the Teign estuary.

At its mouth the river, checked by the sea, deposited a mass of broken rocks, silt and sand which gradually built up a bar across the mouth of the estuary. The water coming down from the moor, deflected by this barrier, took a sharp turn southwards and cut a way for itself around the foot of a cliff – the Ness. From the high land of Haldon several smaller streams also poured down to the sea. The most important of these was a rivulet, the River Tame,

which rose on Holcombe Down and coursed down across the present New Road, Ferndale Road, Paradise Glen and through Lower Brimley to meet the Teign in a broad estuary which stretched from Gale's Hill to Osmond's Lane. This rivulet is almost as important as the Teign in the history of Teignmouth. There is a band of New Red Sandstone along the coast between Dawlish and Teignmouth, backed by a layer of grit over which lies the Haldon greensands, topped by Haldon flint. The heaving earth has long since become stable.

By the year 20,000 BC the major physical features of the Teignmouth area had been formed. Fifteen thousand years later, around 5000 BC, the caves at Brixham and Kent's Cavern at Torquay had become the home of primitive man who hunted the brown bear, the mammoth and the sabre-toothed tiger. Although there are no records of inhabited caves in the Teignmouth area, it is likely that prehistoric man fished in the river and hunted over the surrounding hills. Neolithic folk built themselves houses on Haldon near the Belvedere (the remains of two wooden huts can still be seen) and, no doubt, came down to the seashore to gather salt in order to preserve their meat. There are several Bronze Age tumuli also to be found on Haldon, the most important being near Castle Dyke, off the Ashcombe road.

A few centuries before the birth of Christ, England was invaded by the Celts who developed the skill of working with iron. They were a blue-eyed people, taller and blonder than the earlier inhabitants, who liked nothing better than to drink mead, or heather ale; to feast, to roister and to tell stories of their prowess in battle. They were musicians, poets and artists and some incredibly intricate and beautiful metal work has survived from their day. We usually call them 'the Britons' since they called the country *Prydain* which can be pronounced 'Britain'. Devon was, to them, 'the land of dark valleys' or, in their tongue, *Dyfnaint*.

As time passed they intermarried with the people whom they had conquered – the smaller, darker natives, some of whom preferred to flee to the hills of Dartmoor where they lived as a race apart, feared by and fearful of the British who hemmed them in with hill-forts such as Cranbrook and Prestonbury in the upper Teign valley. It seems probable that it was the small, dark, moormen who painted themselves with woad and were called by the Romans the *Picti* or 'Painted Men' were the original pixies, and they may have survived on the moor until comparatively recent times.

The Celts, or British, certainly did not colonise Teignmouth, since the site was uninhabitable. The whole of the centre of Teignmouth was then a marsh formed by the estuary of the Tame, trapped at its mouth between the sandbanks of the Den and the rising land behind the town. From the present station yard downwards the land was flooded at each high tide by the inrush from the Teign and by the water brought down by the Tame. It was no place to make your home. The drier slopes of Haldon, the rising land of

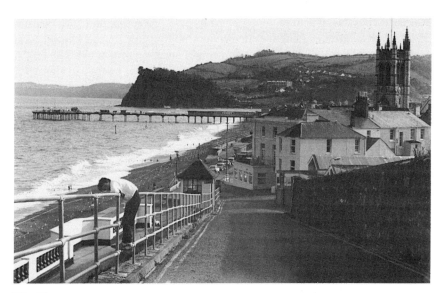

The Ness

Bishopsteignton, the hills on the south side of the Teign were far more suitable and it was in these places that the first settlements were laid down. Ringmore on the Shaldon side of the river dates from very early times. Its name is a corruption of *Bryn Maur* – Celtic for Great Hill. The name Dawlish, too, is Celtic in origin coming from *Deaul-isc* or Devil Water – no doubt referring to the unpredictable nature of the stream which now flows through the centre of the town.

The coming of the Romans did not make such an impact on Devon as it did on the rest of the country. Exeter was a Roman station of some importance and the centre of Roman power in the district, but there are few evidences of Roman occupation west of the city. For the sake of trade the conquerors kept up the system of British trackways within the county, but they only adapted the existing roads – the tracks which ran from moorland to sea used for the collection of salt and the routes across the moor used for the transport of tin – all of which had been trodden for centuries past and ran straight across hillside and valley, the routes being marked by crosses and beacons. Almost certainly there was a salt-track running down from Haldon, along the ridge of Exeter road, to the sea-shore at Teignmouth.

Up to about 250 AD Britain was comparatively peaceful, but from that date onwards communities up and down the coast were harried by Saxon pirates. By the end of the third century the Roman Empire was breaking up under the onslaught of rebellious tribes. British families moved inland, away from the

seaboard. Earthworks were constructed to give protection and early warning of the raiders' attacks. The fortified mound still visible on the hillside across from Bishopsteignton was built at this time. The long drawn out 'Hoo-oo' (in later centuries to be used by fishermen's look-outs, or 'huers', to signify the presence of a shoal of mackerel) from the watcher on the hill, would send villagers scurrying to safety, driving their flocks and herds before them. There may also have been another look-out on the hillside above Wear Farm; 'Wear' may derive from an old English word meaning watch-post.

When Roman troops withdrew from Britain in the fifth century AD there was a gradual decline in civilised living. The inhabitants of Devon and Cornwall, known as the West Welsh, reverted entirely to Celtic ways. As the centuries passed, the whole of Britain fell under the Saxon sway. The invaders, who consisted mainly of three groups – the Angles, the Jutes and the Saxons, but who are usually just called Saxons – came from the marshy lands of Northern Germany and the Netherlands where they farmed the heavy, wet soil and lived on artificial mounds. In England they invaded the river valleys and tended to settle on the rich, damp soils of the lowlands. The British fled before them and settled in the hills, where the soil was light and gravelly and could be turned by their light ploughs.

There were battles aplenty. Sometimes the invaders were driven off, only to return a few years later. Many British chiefs – of whom the legendary King Arthur may have been one – put up a stiff resistance. There is a record of one such skirmish on the banks of the Teign. According to the chroniclers Wace and Layamon, in the time of King Arthur (*ie. c.* sixth century AD) Cador, Earl of Cornwall, pursued Childric, the Saxon Kaiser, and his troops as they fled towards their ships which were moored on the Teign. (It is tempting to think that this incident occurred in the Teign estury and that the boats had been beached on a sand-bank in the river at low tide, but opinions differ). Cador overtook the invaders and his churls, armed with 'bats and pitchforks', and slew a large number of Saxons.

> Then saw Childric that it befell to them evilly; that all his mickle folk fell to the ground; now he saw there beside a hill exceeding great; the water floweth therunder that is named Teine; the hill is named Teinewic; thitherward fled Childric with his four and twenty knights … and Cador heaved up his sword and Childric he slew … in the Teine water he perished.

The 'great hill' makes one immediately think of *Bryn Maur* (Ringmore). But what was there to tempt the Saxons ashore? The settlement must have been too small to suggest much plunder, yet the mooring of the ships in the river – on a sandbank – is very possible. Furthermore, centuries later – in the

eleventh century to be exact – the crossing from Shaldon to Teignmouth and the ferry dues are recorded as part of the perquisites of the Earl of Cornwall (who also called himself King of the Romans, a title dating from the sixth century). Could these have been a hereditament from a grant made to Cador?

The village at Bishopsteignton would have been a more lucrative place for the Saxons to plunder, and Mr Nigel Walker places the affray at Walsgrove or Wolfsgrove Bishopsteignton, – deriving the name of the place from the Saxon *Wael*, or 'place of slaughter'. On the other hand the word *wic* or 'wick' was used by the Saxons to denote a trading-place. Highweek springs to mind – the high trading-place, on a great hill. However, it seems unlikely that the Saxons would have penetrated so far inland if they were only a small body of men.

By the middle of the seventh century AD the valleys of the lower Exe and the Creedy were completely occupied by the Saxons. In Exeter the British lived fairly amicably cheek by jowl with their conquerors, but the rest of Devon remained predominantly Celtic and was ruled by a British monarch. The Celts, or British, were mainly Christians, having been converted to that religion by missionaries from Ireland. Celtic churches had been established in many towns. Kenton had a church dedicated to St Petrock from the early sixth century. Ringmore, too, had a church dedicated to St Nicholas of Myra, and there was a church at Bishopsteignton, a settlement which had the Latinised name of Taintona. These parishes are mentioned in the rolls of Honorius, Bishop of Canterbury, 623-658, when he settled land boundaries and named parishes. Crediton then became the centre for Christian worship for the whole area.

The Saxons on the other hand were largely heathen. St Augustine had begun his mission to Britain in 596 and had met with some success in the east of the country, but the West British clung to their Celtic church, which was regarded by Augustine as a false form of Christianity, and the West Saxons clung to their pagan beliefs. There were still battles between the two races, but gradually the Celts settled down to accept their conquerors. The invaders and the invaded could not have been more dissimilar – the boisterous, Celtic braggarts, free men, always ready for a fight but just as ready for a draught of ale and a rollicking song by the camp fire, and the slower, more deadly and more organized Saxon, bound in loyalty to an elementary feudal system, determined to steam-roller his way over all resistance. Ammianus Marcellinus, the fourth century Greek and Roman historian, describes the Celts as follows:

> Most of the Celts are of tall stature, fair and ruddy, terrible in the fierceness of their eyes, fond of quarrelling and overbearing in arrogance. In fact a whole band of Roman soldiers is unable to cope with a single one of them in a fight. If he calls his wife she is much

stronger than he and with flashing eyes she swells her neck, gnashes her teeth and poising her huge white arms begins to rain blows mixed with kicks like stones discarded from the plaited strings of a catapult.

But fighters though they were the Celts were no match for the stolid, determined Saxons who followed their chiefs into battle with a mindless courage and an unquestioning loyalty which would accept death rather than dishonour. Here is an exhortation made by a Saxon chieftain who was facing defeat in the battle of Maldon:

> Our spirits shall be sterner, our hearts keener, our courage greater as our strength fades. Here on the ground lies our lord, a good man cut down. The man who thinks of leaving the battle now shall regret it for ever. I am old; I will not run away, but intend to lie dead alongside my lord, so dear a man.

The differences in character between the two races is never so clearly indicated as in their attitude to Christianity. The Celts accepted it with enthusiasm and passion and celebrated it with ceremony and song. The Saxons regarded it suspiciously but their innate cautiousness and love of superstition made them accept it in case there was some truth in it after all. One chieftain is recorded as saying that he had gone through the washing (baptism) 20 times, though he regarded the garment given him (the alb) as unfit dress for a warrior. Because of this difference in the temperaments of the two races, where the Saxons settled the old religion and pagan customs remained or were absorbed by the newer Christianity. Churches were built on pagan sites and sometimes seem to have served dual purposes. One such church in the Teignmouth area is the now ruined chapel of St Mary at Lidwell on Haldon. Originally this site must have been used to worship the goddess of the spring which still remains in a corner of the chapel and is known as Our Lady's Well.

The Saxons pushed inexorably westwards. In 682, 'Centwine, the Angle, drove the Britons of the West 'as far as the sea, at the sword point.' The sea mentioned may be the natural boundary made by the Teign or more possibly, the Dart or even the Tamar. The conquest of Devon, however, was still not complete, and the defeat by the Saxons of Geraint of *Dumnonia* (Devon) was but one more step in the slow but sure Saxon advance. By this time *Taintona* (Bishopsteignton) and *Bryn Maur* (Ringmore) were in the hands of the conquerors.

In 800 Egbert made another attempt to extend Saxon rule in Devon, but he was hampered by the fact that the Saxons themselves were being harried by a new invader. A new race of marauders was sweeping down through Britain –

the Norsemen. Each summer fierce Norse warriors, known as Vikings, were setting out to plunder and pillage richer lands for spoil which they bore home to Scandinavia before the winter storms began. The Saxon settlers in England began to complain that the sea, which was formerly their friend, was now their enemy because it bore the bloodthirsty Vikings.

The people of Bishopsteignton and Ringmore, tilling their tiny fields on the well-drained hillsides, tending their saltpans and fishing and hunting along the Teign, heard terrible stories of the havoc wrought by the Norsemen in other parts of the country and feared that sooner or later their own peaceful life would be disturbed. Travelling tradesmen brought them news of raids along the south coast and look-outs were warned to keep a sharp watch for the dreaded long-boats nosing their way among the sandbanks at the river mouth. Children were bidden to come from play at the first shout. Cattle and sheep were kept near the village stockades. In the evenings people gathered together to hear stories sung in rude verse about the mighty deeds of old and about present catastrophes.

They lived a simple life, their staple diet being fish and molluscs, coarse bread and gruel, beans and wild fruits. They worked from dawn till dusk and lived in tiny cob-built hovels which they often shared with animals. The houses consisted of one room only, with a central hearth and a rough thatched roof with a hole in the middle to aid the escape of smoke. Salt to preserve and increase the savour of their food was made in the salt-pans alongside the little river Tame in Teignmouth and at Salcombe between Teignmouth and Bishopsteignton. At Teignmouth, on the east side of the Tame where the land was beginning to rise, it is likely that they built a small wooden chapel dedicated to St Michael for the blessing of fishermen before they put out to sea.

About the year 800 the thing they most feared may have come about, although there is some debate whether the event occurred in Devon or at Tynemouth in Northumberland. Camden reports:

> Tinemutha, a little village at the mouth of the river Teine whereof it also hath the name; where the Danes that were sent before to discover the situation of Britain and to sound the landing places being first set ashore about the Year of Salvation 800 and having slain the Governor of the place, took it as an ominous good token of future victory, which indeed afterward they followed with crueltie through the whole island.

This statement is confirmed by Risdon but disputed by other chroniclers who argue that the first Danish raids were concentrated on eastern and north-eastern Britain; that there was no village at the mouth of Teign (although Taintona-Bishopsteignton might qualify.) There are many ifs and

buts and it is doubtful we shall ever know the truth.

In 865 however, a great army of Vikings settled in Kent and the whole of the country was gradually over-run. In 877/878 the Danes in the Exeter district were out-manoeuvred by King Alfred and forced to make peace. They were defeated in the same year by the 'theigns of Devon' and after that the bloodshed was not as great.

The Anglo-Saxon Chronicle contains many references to incursions into Devon by the Danes between the years 8OO and 1,000. Many stratagems were adopted to foil the invaders and mercenaries were hired to supplement the English forces. Pallig, a brother-in-law of Sweyn, King of Denmark, was a mercenary hired by King Aethelred to protect the British coasts on the principle of setting a thief to catch a thief. This manoeuvre was not successful. In the year 1001 Pallig turned traitor and joined his countrymen in rapine and pillage. The Anglo-Saxon Chronicle states:

> ... the Danes went westwards until they came to Defenas (Devon) and there came to meet them Pallig with the ships that he could muster.... And they burned Teignton and also many other good vills which we cannot name; and peace was afterward there made with them. And then they went thence to the mouth of the Exe, so that they went up in one course until they came to Penhoe; and there were Kola, the King's High Reeve, and Eadsige, the King's Reeve opposed to them with the force that they could gather; and they were put to flight and many were slain and the Danish had possession of the place of carnage.

An interesting footnote to this occurrence is that the Vicar of Pinhoe to this day receives as part of his stipend the equivalent of one Saxon mark (13/4d in old money). This was awarded to his Saxon predecessor almost 1,000 years ago as a permanent pension – the reward for his bravery in crossing the Danish lines with his donkey and returning with a supplementary load of arrows for the Saxon defenders who had run short. The sum, which is supposed to represent the cost of feeding a donkey for one year, is charged against the National Debt.

Teignton has variously been described as Kingsteignton and Bishopsteignton. The latter interpretation must be the correct one. In the same chronicle, Bishopsteignton is later referred to as a manor. All manors were founded between 449 and 1307. They were instituted soon after the landing of Hengist and Horsa in 449 and abolished at the end of the reign of Edward 1. Bishopsteignton had been designated as a parish since the seventh century – as *Taintona* – and so was well established by 1001. As a manor it would have been surrounded by a thriving village. It is unlikely that the Vikings would have passed such a prosperous looking place to plunder the small hamlet of

Kingsteignton which could only be approached across difficult and marshy terrain. Furthermore, there is in Bishopsteignton, at Ashill, a field marked on the Ordnance Survey as 'Peacefield'. This is traditionally the place where peace was signed with the Danes.

By the eleventh century the Teignmouth area was well and truly in Saxon hands. In 927 the last of the British resistance led by King Howell had been stamped out by King Athelstan at the battle of Haldon Hill. The Celts withdrew into Cornwall and Athelstan celebrated his victory by founding a monastery at *Taintona* (now known as Old Walls. The ruins can still be seen at Ashill) – further proof of the flourishing condition of that village. In the following years the Bishopsteignton (Teignton of the Bishop) began to replace Taintona. Athelstan,too, built or rebuilt a church in the village, which he caused to be dedicated to St John the Baptist. Later the monastery became a Benedictine community which remained there until about 1050, when the structure fell into disrepair. During their occupation the monks walled and brought into use a well at Whitewell, not far from their settlement, on the southern slopes of Haldon.

In 1044 Edward the Confessor made a grant of land to a churchman, Leofric, of Crediton. The charter can still be seen in the Cathedral Library at Exeter. The body of the deed is in Latin, but the boundaries of the land conveyed are in Saxon – probably to facilitate local understanding.

I, Edward ... have granted to a certain worthy chaplain of mine called Leofric, a certain tract of land in the vill which the inhabitants of that region call Doflisc, that is to say seven manors of ploughland in that place, by the tenure that it shall be governed honourably under his dominion and power all the days of his life and without any machination, and that he shall have power after the end of his days of appointing or nominating the same to whomsoever he pleases

These are the land boundaries: First at Tengemudan (Teignmouth), up along the estuary to crampan-steort, and so back again by the salterns along the street on the west side of St Michael's Church, and so north along the street to the great dyke: thence north back right on to the blind well, from the blind well north straight on to the downstone, thence back right along the old dyke north right on over the watershed combe; thence up along the row of old staples right along the ridge to the sand hollows, along the street to the black penn; thence along the street to the top of the broad moor; and thence right along the street to the earth forts and so north along the street to the stone heap, and so down along the street to Doflisc ford and thence north from the ford along the market street to the head of the valley of rushes, so down along the stream to Cocc ford; and so along the estuary out on Exe;

15

down back along Exe to Sciterlakes outfall and so up along Sciterlakes to the estuary head, thence forward south on the old dyke and so right on to the red stone, from the stone south out to sea, and so west by the sea back to Tengemudan.

These boundaries are interesting. *Crampan-steort* or 'Anchor Point' was almost certainly the sandbank thrown up between the mouths of the Tame and Teign and shaped like the fluke of an anchor. The salterns were on the banks of the Tame since fresh water was needed for the Saxon manufacture of salt. The word 'street' simply meant a road so there is not necessarily any evidence of houses in the area although the salt works may have indicated huts. The 'great dyke' ran down Dawlish Road and the 'blind well' (a well without a visible opening) was situated on the east side of Woodway Road and a little north of New Road, immediately behind a house called 'Wilbraham'. The well is still there, but built over. The downstone – a landmark which has

The Tame (Brimley Brook) as it flows through the grounds of Trinity School

vanished long since – possibly situated at the top of Break Neck Hill to mark the boundary of Haldon Moor, and the 'watershed combe' was certainly the top of the valley formed by Dawlish Water. The 'earth forts' were probably Castle Dyke; Dawlish Ford and Cocc Ford are easy to identify, but the 'black penn' – literally the black promontory – is more difficult. The 'valley of the rushes' is obvious – it is the little valley still thick with rushes and weeds through which the stream meanders and which we call Cockwood Marsh. The *Sciter* is, of course, the Shutter stream and *Sciterlakes* where the Shutter enters the Exe. The 'red stone' was probably a cliff of red sandstone which has now crumbled away. It may have stood on the western bank of the Exe since that river in former times emptied into the sea on the western side of Dawlish Warren which is shown on old maps as an island.

When Lyfing, Bishop of Devon and Cornwall, died in 1046, Leofric succeeded to the See. Four years later he moved the See to Exeter. Danish raids were continuing and Crediton had next to no defences. Already one bishop had been murdered at nearby Copplestone. Exeter with its ruined walls, set on a hill above the river, was a safer place.

In 1050, too, Leofric received another grant of land which included what is now West Teignmouth and Bishopsteignton and extended as far as Chudleigh. The bishop now owned all the land from Dawlish in the east to Chudleigh in the west. He divided the western grant into four manors – Radway, Taintona, Lindridge and Luton. At the time of his death (1073) these manors are listed as belonging to the See of Exeter.

2 THE BIRTH OF THE TOWN

The year 1066 was a fateful one for England. Edward the Confessor died on 5 January. On his deathbed he nominated Harold, son of Godwin, as the next king, but since kingship in England was by election, this had to be ratified by the Witan. William Duke of Normandy, however, claimed the throne by reason of his kinship with Edward and because he said that both Edward and Harold had promised him that he should be the successor. Harold assumed the crown and set about quelling various rebellions within the country and beating off the Danish raiders. It was a difficult and ominous year. In the spring there were signs and portents in the heavens. Halley's comet – a phenomenon which the Saxons were unable to explain – blazed across the sky leaving 'trails of blood'. Cattle died of a murrain and what had been clear and limpid springs turned thick and undrinkable. In Normandy, William was preparing a fleet to invade England.

The invasion took place in the autumn and on 14 October Harold was slain at the Battle of Hastings. William was crowned king on Christmas Day and his wife Matilda – the first queen of England – was crowned early in the following year. William's policy to keep the rebellious English in subjection was to replace the Saxon lords with Normans wherever possible, but at the same time he was careful that no man should gain too much power. He imposed the strict feudal system of the Normans and divided England between a number of overlords to whom lesser lords owed allegiance and duty. The West Country was given to his half-brother, Robert, Count of Mortain.

It was abundantly clear to Leofric, who held the tract of land comprising Dawlish and East Teignmouth, that he must gain the king's goodwill. Therefore he handed over to William some of the land which he had been

granted, knowing full well that if he had not it would be taken from him. Surprisingly – possibly because he wanted to stand well with the church – the king returned the land to Leofric, nor did he replace the prelate with a Norman. The land, however, which had previously been Leofric's to do with as he wished, was returned to him, not as his own personal possession, but as a gift to the Church and was to be used 'for the maintenance of canons'. The charter, which has much the same format as that of Edward the Confessor and is also in the Cathedral Library at Exeter reads thus:

> I, William, victorious king of the English, have agreed to grant to my faithful bishop, Leofric, seven manors of land in private places that is Bemtum abd Estunn, and Ceomannyg and Holacumb to the church of St Peter the Apostle in Exeter, where his episcopal See is, and to increase the maintenance of canon by hereditary right These are the land boundaries ... first at crampansteort to floraheafdo; from floraheafdo up along the way by the west of the church up to ferngara; from ferngara to the downstone; from the downstone up to the dyke; and so east along the dyke to the water; from the water north to the head of the croft and so north to the small path, so upon the down to the thwart dyke; and so to the land boundary of Dawlish, down to the arietes stone and so along the strand to crampansteort.

Dawlish itself appears to have been excluded from the gift: it seems Leofric was able to keep it as his own since it is mentioned in his will in 1073 as one of the gifts which he personally made to the See. The land outlined in William's gift corresponds almost exactly with the modern parish of East Teignmouth, but a strip of land, the valley of the Tame, no doubt worthless because it was largely marsh, was excluded from the charter.

In 1067 Exeter rose in rebellion against the Conqueror, Gytha, mother of King Harold and Edith Swan-neck, his mistress, had taken refuge there and no doubt their presence aided the insurrection. William marched on the town and the rebellion was quickly squashed. Rougement Castle was built by the Normans to prevent further trouble. It is inconceivable that the inhabitants of the Teignmouth area were not involved in this struggle, so near to their homes and involving the bishop, their immediate overlord. Tradition has it that it was a man from Bishopsteignton who offered to the Normans beseiging the city the ultimate Devonian insult: he climbed on the city walls and exposed his buttocks to the enemy – a rash act considering the efficiency of the Norman archers.

There is some confusion as to the ownership of land after Leofric's death. Immediately, both *Taintona* and Dawlish (including East Teignmouth) were in the hands of the Church. This state of affairs continued for some while, but

in the succeeding years there must have been changes. The Domesday entry for *Taintona* is as follows:

> The Bishop has a manor called Taintona, which rendered geld in the time of King Edward for 18 hides. These can be ploughed by 55 ploughs. Of them the Bishop has 5 hides and 4 ploughs in desmense: and the villeins have 51 ploughs and 13 hides. There the Bishop has 57 villeins, 35 Bordars and 14 serfs, and 10 swineherds who render yearly 35 swine and 2 packhorses, 37 head of cattle and seven swine and 400 sheep and 50 goats; 9 houses in the borough of Exeter which render yearly 3 shillings, and 24 saltworks which render yearly 10 shillings, and of wood 1 league in length and as much in breadth, and it is worth 24 pounds, and when the Bishop received it it was worth 14 pounds.

It appears from this that Taintona, which obviously included West Teignmouth, had prospered under the management of the bishops. It was a large manor comprising at least 117 men plus wives and children, a not inconsiderable number when one considers that the population of England was only about 2 million. The saltworks mentioned are noted as the largest west of Exeter but they are probably not those mentioned in the charter of Edward the Confessor since thes would fall outside the manor boundaries. They must, therefore, either have been at Salcombe on the Teign or else on the western shore of the Tame estuary. The latter is possible, or the chronicler may have been wrongly informed.

East Teignmouth figures in the Domesday records as part of the manor of Dawlish for which the entry reads:

> ... the Bishop (Osbern) has a manor called Douelis which in the time of King Edward paid geld for 7 hides. These 30 ploughs can till. Therof the Bishop has 1 hide and 2 ploughs in demesne and the villeins have 6 hides and 24 ploughs. The manor is assigned for the support of canons. There the Bishop has 30 villeins, 8 bordars, 3 serfs, 3 cows, 2 swine, 100 sheep, a coppice 3 furlongs in length and 1 in breadth, 6 acres of meadow and 12 acres of pasture. It is worth £8 a year. When the Bishop received it is worth?

No saltworks are mentioned so that at first sight one is inclined to think that East Teignmouth is not included. It is likely, however, that East Teignmouth was included in the Dawlish record. No entry for it appears anywhere else. The omission of the saltworks in Dawlish and the inclusion of large saltworks in *Taintona* can only be explained by the premise that for reasons best known to himself the bishop falsified the return to the extent that he transferred the

East Teignmouth industry to West Teignmouth - after all the boundary was a mere stream. Further, a market charter granted to East Teignmouth in 1253 refers to the ancestors Philip de Furnell as the owner in the time of Henry I (1100 - 1135). Confirmation of the grant of free warren in the manor of Dawlish was made to Philip in the time of Henry II and refers back to the fact that his ancestors held it in the reign of Henry I. If Philip's forebears owned both East Teignmouth and Dawlish in the reign of Henry I the chances are that the two were not separate at the time of Domesday.

Be all this as it may, the situation in Domesday times was clearly that there were settlements at Bishopsteignton and Dawlish, but that Teignmouth had no value (other than the saltworks). There were probably a few fishermen's huts, hovels for the saltworkers and a rudimentary chapel or church on or near the site of the present St Michael's.

The Domesday entries, however, do give us some insight into the lives of the people of *Taintona*. They worked long hours for the lord of the manor, tending their strips of common land whenever they had the chance. Sheep formed the bulk of the animals in both manors so sheep-herding was an important part of their lives. The English wool trade was an extremely valuable part of the national economy.

Roast mutton was a luxury forbidden to anyone outside the lord's household, but 'bracky mutton' – the meat from a sheep which had died from a disease and so was deemed uneatable – found its way into the cooking pots in many a village hut. This was an illegal act and could be severly punished. Most peasants had a pig from which they obtained lard for their bread. No part of the animal was wasted. The skin was tanned to make shoes. Surplus meat was salted and kept for winter, the blood and entrails were made into sausages. Butter was almost unknown to the villager. Bees were kept on the common land for honey – their only sweetener. Beans, the leaves of ground elder and 'fat hen' (*chenopodium album*) were their chief vegetables. Onions were eaten with almost everything. Near the coast fish and shellfish were eaten abundantly. Geese were run on the common, but usually found their way to the lord's table. Apples there were in autumn and a few pears and plums. Herbs were used to cure most sickness and 'wise women' (later known as witches) gave medical advice, bound up wounds with the leaves of plants and with cobwebs and uttered spells and incantations. Hygiene was non-existent and this accounted for the prevalence of many skin diseases – all of which were called leprosy. Lepers were segregated from the community.

Clothes were simple and workmanlike. The villeins wore a stuff tunic with hose or long knickers, leather shoes and a cap. The women wore loose shifts covered by ankle-length tunics, and a super-tunic, or *vroc* (forerunner of the frock). The hair was covered by a *viel* which they wore even in bed.

Attendance at church was compulsory and the church bell was instituted so

that no one had any excuse for missing services. The rest of Sunday was regarded as a holiday and only necessary work was done. The Bible was in Latin which hardly anyone understood, but they knew the meaning of the service by rote. The village priest was usually the younger son of the lord of the manor – and the church was his livelihood: this was another reason for the demand for strict attendance at church. People professed to be Christian, but traces of the old religions remained. Many former pagan customs and festivals were still celebrated, and the church, wisely, did not attempt to stamp these out but tended rather to incorporate them in Christian rituals and feasts. Christmas was fixed to coincide with the feast of Mithras; Easter took over from the Saxon feast of Eostre (the dawn of the growing season); Samhain became All Saints.

In spite of plague and cholera, smallpox and diptheria the population of England slowly increased. The child mortality rate was as high as 50% in the first year of life, but birth control was unknown. The life expectancy of both men and women was under 40 years.

On the whole the Norman administration was a good one although it was biased against the Saxons. Justice was strict. It was administered by the lord of the manor who was judge and jury. Trial was usually by ordeal for such offences as heresy, on the premise that God would exonerate the innocent, but it is interesting to note that if a murdered person had fair hair, and so was adjudged a Saxon, the murderer escaped the extreme penalty.

Like the Saxons the Normans, too, laid great emphasis on loyalty. It was, after all, the foundation stone of the feudal system. The Norman's oath of fealty to his lord was; 'I become your man for the tenement I hold of you, and faith to you I will bear of life and limb, and earthly worship and faith to you I shall bear against all folk.'

In *Taintona*, since the bishop, the overlord, was in Exeter, an overseer managed the estate.

The coastline of Teignmouth by the beginning of the twelfth century was very much as it is today, but the Den was a sandbank separated from the land by the marshy estuary of the Tame. A footpath to Dawlish went up the cliffs and then inland by way of Oak Hill Cross Road to the village which was built near the church and was separated from the sea by a salt marsh. Another footpath went from Teignmouth along the banks of Bitton Brook and then inland to Ashill. The route to Exeter went over Haldon. Gorway Cross, (formerly Goddaway Cross) a great lump of unhewn granite stood a mile north-east of the town and marked the boundary between East Teignmouth and Dawlish. The salt-pans of Teignmouth were very important in Norman times, and as the population of the area grew so their output had to increase. They were undoubtedly responsible for the birth of the town since as times became more settled and Viking raids ceased, people came to live along the

banks of the Tame. There were two hamlets – one on each side of the stream – East Teignmouth under the auspices of Dawlish; West Teignmouth belonging to the manor of Bishopsteignton. Of these, West Teignmouth was the larger, although there was no church nearer than Bishopsteignton – that was considered near enough. In 1107 the church of St John at Bishopsteignton was rebuilt on its old Saxon foundations. It is said that a Saxon arch remained for several centuries. East Teignmouth, on the other hand, certainly had a church – the Church of St Michael.

A church was always regarded as a place of sanctuary for the medieval criminal. Once within its walls he could not be arrested and he could stay there safely for 40 days, fed by his friends or well-wishers. At the end of that period he had to abjure the country (go into voluntary exile) or remain in sanctuary and starve to death. Free men – those men not tied to a lord – were few and far between. Bondmen could only obtain freedom by buying themselves out – a costly business – or by the generosity of their lords. Life in Teignmouth must have centred round the Manor of Bishopsteignton, but the monastery at Old Walls was important too. The monks, the only truly literate members of the community, trained a few young men in the arts of clerkship. They offered, too, succour in times of extreme distress and sickness. Services were paid for in kind. Money was scarce. In 1254, Henry III passed a law requiring anyone with an income of more than £10 per year to be compulsorily knighted. £10 was a fortune. It was a good way of increasing the income of the royal exchequer through knightly dues. There were very few knights in the Teignmouth area.

In 1235 William Brewer, Bishop of Exeter, handed over several manors to the Dean and Chapter. One of these was Dawlish with East Teignmouth, which so passed out of the hands of the bishopric.

At this time the Manor of Bishopsteignton was in decline and the monastery at Old Walls was no longer used as such. A country house, or palace, for use by the bishop when Exeter was not habitable because of the summer heat, or by reason of the plague, was built there at some time in the late twelfth century; it is mentioned in a deed of Bishop Brewer, 1238. The Lysons state that by 1291 the monastery was dilapidated and largely pulled down.

Meanwhile Teignmouth was growing. In 1256 Bishop Richard Bondy confirmed a gift to West Teignmouth of 300 acres of land probably, since it was a century devoted to land reclamation, an area reclaimed from the estuary of the Teign at Lower Bitton and including what is now Lower Bitton Sports Field. This gift finalized the growing division of West Teignmouth from Bishopsteignton and established the parish as a separate village. In the same year the bishop obtained a market charter for West Teignmouth which infers a growing population.

It appears that the inhabitants of East Teignmouth had been holding a

market without warrant for some years. Risdon states that the Sheriff of the Shire was called upon to suppress this since the inhabitants refused to cooperate. In 1253, however, the Dean and Chapter of Exeter obtained a charter for East Teignmouth and from that time onwards a market was legally held on Saturdays. There was also an annual fair. The granite stump of the old market cross which at first stood on the rising ground near St Michael's Church and moved to various sites in the succeeding years, now stands on the plot of grassland which lies between the end of French Street and Regent Street. The charter reads thus:

> We have also granted to the Dean and Chapter that they and their successors may hold in perpetuity in their manor of Teignmouth a market on the Saturday of each week, and that they may hold there one fair in each year lasting for three days, namely on the Eve, on the day itself of St Michael, and on the day after, unless such market and such fair shall be to the hurt of neighbouring markets and neighbouring fairs.

The charter for West Teignmouth granted in 1256 is not extant. Someone forged the great seal; and it seems that the endorsement of the document was questioned. In 1270 a new charter was issued to validate the former one. It reads thus:

> ... know ye that we have granted and by this our charter have confirmed to the Venerable Father Richard, Bishop of Exeter, that he and his successors in perpetuity may have one market on the Thursday in each week in their manor of Teignton in the county of Devon, and one fair in the same place every year lasting for three days namely on the Eve, on the day itself of St James the Apostle, and on the day after, unless that market and that fair shall be to the hurt of neighbouring markets and neighbouring fairs Given under our hand at Windsor on the 21st day of January in the 40th year of our reign ... Henry III This was the substance of a grant under our former seal which we used and because after a time that was imitated, we have passed our aforesaid charter under the seal which we now use for signature.

This charter was obtained by Bishop Bronescombe who died at Old Walls in 1280.

It was manifestly to the advantage of the Church to encourage the growth of the new village – more prosperity meant more tythings – and the markets and fairs vastly increased the revenue. Things did not run altogether smoothly, however. Perhaps the bishops were greedy. In 1274 there appears a complaint

in the Hundred Rolls from the inhabitants of Teignmouth which states that the Bishops of Exeter had held a market illegally for the past seven years 'on the Saturday following the feast of St Michael, which market ought to be in the town of Teignmouth in the part of St Michael which belongs to the Dean and Chapter.' Simply, the bishops, owners of the Manor of West Teignmouth, were holding a market in East Teignmouth on the day devoted to the market belonging to the Dean and Chapter. This must have been with the connivance of the Dean and Chapter who would otherwise have been the complainants.

There are also complaints that '... the Dean and Chapter of Exeter in Dawlish and the Bishop in Bishopsteignton had for some time past had gallows and assizes of bread and beer, they know not forsooth by what warrant....' Also 'that the Bishop of Exeter has a warren in Chudleigh and Bishopsteignton since the coronation of Henry, father of the present king and moreover that the Dean and Chapter have a warren in their manor of Dawlish, they know not by what warrant....' The last complaint was disallowed, the Church proving that they had 'free warren' by former charters in each locality. The matter of the 'gallows and assizes of bread and beer' does not seem to have been resolved and there is no further mention of the illegal markets. (A warren was simply a hunting ground for small mammals.)

Meanwhile the port of Teignmouth – within the boundaries of West Teignmouth – was growing in importance. In 1254 Roger de Evesham was sent to Teignmouth as one of the several clerks visiting English ports, to 'arrest all ships able to carry 16 horses'. These vessels were required to be at Portsmouth by the following Easter in order to carry 'Edward, the king's son and Richard Earl of Cornwall' and other important persons, to Gascony.

In the summer of 1291 a whale was cast up on the shores of Teignmouth. It must have been within the boundaries of West Teignmouth since it was the bishop who complained bitterly:

> ... that whereas a whale by inundation of the sea was cast up on his land at Teyton in the County of Devon, within his liberty, which by charters of the king's ancestors fell to him as a wreck of the sea, certain persons carried away the same night

An enquiry was instituted but the whale was never found. The animal could be put to many uses. Not only was the meat edible, but the blubber produced oil and the bones could be used in a variety of ways. The bishop was in Exeter when the event occurred. The whale was in Teignmouth, and news travelled slowly.

In the following year, 1292, Thomas de Bytton was appointed Bishop of Exeter. Thomas came from Bitton near Bath from which he took his name.

He is remembered for two reasons: the first that he had an unusually fine set of teeth in an age when teeth were blackened and rotted early in life. A legend grew up around this marvel and even in the late nineteenth century persons from Teignmouth suffering from toothache made a pilgrimage to the bishop's tomb in Bath Abbey where their pains were miraculously cured. Secondly, the bishop appears to have built for himself a house within the bounds of West Teignmouth – possibly, at Lower Bitton, where he occasionally stayed when in the area. He gave his name 'Bitton' to this part of Teignmouth. His desire to stay in Teignmouth was accented by the fact that the old palace at Bishopsteignton was by this time in disrepair. Today, all that remains of the monastery and palace are some ruined walls with Saxon windows and a holy water stoup. The rest of the structure is incorporated into farm buildings. In recent years there has been a move to preserve these relics since Mr Dawe, the farmer, is keenly interested in their history. They are, he realises, the remains of some of the earliest buildings in Devon.

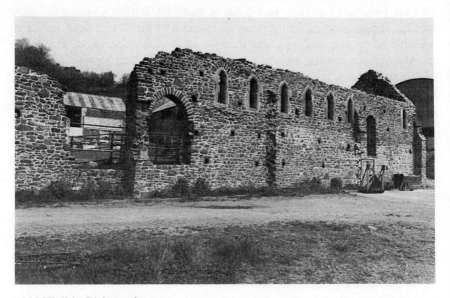

'Old Walls', Bishopsteignton

3 THE YEARS OF GROWTH AND DECLINE

In 1272 Edward I had come to the throne of England. He was a powerful and warlike king, determined to brook no opposition from anyone at home or abroad and to this end he demanded his dues under the feudal system. In pursuit of his war against Scotland (he had already subdued Wales) he demanded ships from various towns, one of which was Teignmouth. It appears, however, that the order was never satisfied because in the Originalia Rolls, 1302, the following punishment order appears:

> The King to his trusty and well-beloved Thomas de Verblynngton and Peter de Donewich, Greeting. Whereas the Commonalities have agreed that the towns of Seaford, Shoreham, Portsmouth, Southampton, Lymington, Ermme, Poole, Wareham, Lyme, Teignmouth, Plymouth, Fowey and Bridgewater, shall in response to our request send a certain number of ships well armed, to Us in aid of our war against Scotland, namely from the aforesaid town of Southampton, two ships, and from each of the other towns aforesaid one ship, and the said Commonalities however have not taken care to send the ships as they promised, from which we hoped to have great assistance in our expedition of war aforesaid, in contempt of Us and to the manifest hindrance of our expedition Being unwilling to leave such contempt unpunished, we have appointed you to punish all this Commonalities and towns aforesaid ... in such a manner as your true discernment shall see fit.

Possibly the two commissioners did not reach Teignmouth, or possibly they made demands which were ignored, for a few months later Peter de Donewich

and Peter de Chalons were again sent to punish Teignmouth and the two Cornish towns. Three months later the need for ships became very urgent and Peter de Donewich was appointed to act with the Sherriffs of the Counties to induce the bailiffs and goodmen of several ports to send ships, with men and arms for an expedition against Scotland. Teignmouth and Dawlish sent one ship between them. There is some evidence that the towns were basically West and East Teignmouth (not Dawlish as we know it).

In 1307 Edward I died and Edward II came to the throne. The new king continued the war which his father had instigated but without the same vigour and leadership. He soon showed himself imcompetant and frivolous but even so the Close Rolls of Edward II record that the king sent an order to several south coast towns, dated Windsor 10 July:

> To Shoreham, Portsmouth, Southampton, Yarmouth, Lymington, Poole, Weymouth, Lyme, Exeter, Teignmouth, Dartmouth, Plymouth and Bristol to prepare immediately a ship of that port with all appurtenances and armaments and to choose and arm with suitable arms, forty two of the strongest and most able-bodied men ... one of whom shall be master and another constable of the said ship ... to be ready by the Feast of St Peter ad Vinicula to set out then at the latest in the King's service and at his charge to Scotland ... the King proposing to set out shortly for Scotland to repress the rebellion of Robert de Brus and his accomplices He has caused 20 marks to be delivered to his clerk the bearer hereof for the wages of the said men from the day when they leave the said port until they arrive at Skyburnease, and he will cause them to be satisfied for their wages while in his service.'

This order was not implemented because the expedition was aborted. Edward must have been in dire need of ships and very afraid that the towns named would not supply them because it was almost unheard of to offer to pay men wages while on the king's service. The order and its subsequent cancellation are sidelights on Edward's weak and vacillating nature.

On several other occasions during the reign of Edward II Teignmouth was asked to furnish and provision ships – the number usually being two. Dawlish is not mentioned.

In 1317 *La Redecoge* of Teignmouth loaded with supplies for the King in Scotland, was blown off course and ended up in Ireland. The perishable cargo –1,016 hakes, 2,900 congers, and some oats and salt were delivered to Dublin Castle.

It is clear that in the early fourteenth century Teignmouth was a thriving port – trading in fish and salt, and having a population of hardy men. It ranked equally with the other towns of the south coast, yielding only to

Southampton. Such prosperity must be attributed to careful management by the Church which received tythings from both East and West Teignmouth. The houses in which the people lived were still little better than hovels, clothes were rough and serviceable, diet – based mainly on fish was poor but adequate. These conditions bred a race of hardy lawless men who gave lip-service to their overlord in Exeter, but went their own way whenever possible. Smuggling was not unknown. Since no dues were paid to the Church on such transactions, it was a profitable sideline – like the seizure of stranded whales. A merchant named Arnold Wikeman, had his ship – the *Michael* of Teignmouth – which was loaded with wine, seized at Dartmouth by Galfrid de Say, an admiral of the fleet.

Two churches were established in thirteenth century Teignmouth – the ancient Saxon Church of St Michael and the newer one of St James. The East Teignmouth church had been renovated and improved, but it was still very small. It was, in fact, a chapel under Dawlish and served by a curate from there. St James the Apostle built early in the thirteenth century as the charter for West Teignmouth fair (1256) proves, is described in *Croydon's Guide to Teignmouth* (1817) thus:

> It is a very ancient structure of solid stone, roofed with stone and about 18ft high. The tower which is square, is from the base 54 ft high, almost flat on top and covered with lead; it contains four bells which being of old-fashioned make and of great substance are not very musical or tunable. Of the church (built in the form of a cross) the length of the body from west to east (the belfry and chancel included) is 108 ft and the breadth 24ft, which is the breadth of the north and south aisle

Both churches lasted into the nineteenth century. It is clear that St James' was much the larger, but it, too, was a chapel – under Bishopsteignton and served from there. It had been built for worship and defence; the slit windows in the Norman tower which still stands, were designed for shooting out arrows. During recent repairs to the walls the rusted remains of an arrow head were found. Situated on the rising ground overlooking the estuary, the church made an admirable look-out point and place of refuge. In the tower an old and cumbersome ladder believed to date from the thirteenth century can still be seen. The altar of this church is described by Camden as 'of massy stone, very curiously sculpted, with several large niches.'

In the fourteenth century John Kaignes was rector of Bishopsteignton and his curate was John Eustace, who was responsible for St James' at Teignmouth. A group of West Teignmouth men, for an undisclosed reason, 'about Xmas time' set on John Eustace and attacked him with 'diabolical fury',

according to the *Transactions of the Devon Association* (Vol.36). Eustace, inflamed by the attack, incited a man to stab Henry Baker, clerk, with a small hooked knife. As a result of this violence Eustace was suspended from officiating at Bishopsteignton or in its chapels while an injunction of greater excommunication was issued against all those who had been involved in the fracas. It seems that in some way Kaignes, the absentee rector, was held to be at fault, and after his death the priest at Bishopsteignton was a vicar not a rector.

About 1350, Bishop Grandisson who had lived at Bishopsteignton during the preceding three years – the years of the Black Death – built a sanctuary behind Bishopsteignton Church dedicated to St John the Baptist. The field is still known as Sentry or Santry Field.

Apart from the two main churches St James and St Michael there was in Teignmouth at this time a chapel dedicated to St Mary Magdalene, in the northern extremity of West Teignmouth on the right hand side of the road which goes over Haldon to Exeter. In 1791 the ruins of this edifice were still standing and were described by Robert Jordan:

> Several are now living in the town who remember most of the walls standing and the arches of the windows and doors (which were Gothic) entire, and part of the roof on. The walls are now quite demolished and even with the ground. There is an estate in the parish of Bishopsteignton which was obligated to pay a minister for reading prayers in the chapel once a month a certain sum per annum. I think I have heard £20. There also formerly stood near the chapel several Poor Houses where the poor of West Teignmouth then resided – these are also demolished; not a vestige of them to be seen.

The chapel of St Mary Magdalene and the settlement around it began in the early part of the fourteenth century as a poor settlement and leper sanctuary. In medieval times, any skin disease was regarded as leprosy, and the sufferers were made to live outside the community. Their care was usually undertaken by monks. In 1434, Bishop Lacey granted indulgence of 40 days to sincere penitents contributing to the support of the Poor Houses and in the following centuries there are fairly frequent mentions of bequests to Maudlin (as Magdalen was commonly pronounced).

In the twentieth century – until after World War 2 – a house called Hazeldown stood on the site of the leper chapel. The owner, Mrs Stanbury, reported finding quantities of bones buried in the garden – obviously leper graves. A Saxon font found in the grounds, hinting that the settlement may date from earlier than the fourteenth century, is now in the porch of Bishopsteignton Church. Mrs Stanbury said that at times a ghostly bell with a

very deep note sounded throughout the house. Many local people heard it but none could explain it. Parts of Hazeldown were the refurbished ruins of the old chapel. The windows were arched like a church. The outside lavatory was hexagonal, beautifully panelled and had clearly been used as a confessional. During road repairs outside the house some vaulted cellars were discovered. The building was totally demolished in the 1960s to make way for a new estate and the fields which served the chapel now lie under Maudlin development. *Croydon's Guide to Teignmouth* (1817) says that it was then part of the estate of Mr Richard Whidborne who believed that it was still prayed for in Roman Catholic countries. (Mrs Stanbury referred to 'frequent Catholic visitors from overseas'). A few of the older locals still speak of the walk from Hazeldown down Rocky Lane and up Paddon's Lane as 'the lepers' walk.' It is believed that the sufferers were allowed to exercise in this area, but although the Maudlin lands extended to the west side of St James' they were not allowed nearer the town.

A religious community at Venn Farm disappeared from the records fairly quickly. Venn belonged to Walter de Thailleur in 1332 who held it from the Bishop of Exeter for one fifth Knight's fee, according to the Devon Lay Subsidy Rolls. Venn House was built in early Stuart times. In 1672 John Narramore of Venn leased a parcel of Modlin (Maudlin) land to Joseph Hall of West Teignmouth. The chapel of this house was profaned by Bartholomew Narramore, used as a dairy and then demolished, according to popular tradition. Mrs Langley of Shute Hill House, however, stated before her death at the beginning of this century that it was Thomas, grandson of Bartholomew, who committed the sacrilege. Mrs Langley was a descendent of the Narramores.

On the slopes of Haldon the ruins of the chapel of Lidwell remain. The name is a corruption of Lady's Well – the chapel was dedicated to Our Lady. The well – a pagan site originally – can still be seen. In Bishop Grandisson's register there is an entry dated 17 May 1329 referring to the purgation of Robert de Middlecote, hermit monk of Lidwell, who was said to have robbed and murdered travellers who rested overnight in his chapel throwing the bodies into the well – with complete disregard for his water supply. The ghosts of the murdered folk are said to haunt the neighbourhood. After the execution of de Middlecote the chapel became a chapel-of-ease for farmers. There is a passing mention of it in the church records of 1411.

In 1327 Edward III came to the throne and eleven years later the Hundred Years' War began. In 1340 Teignmouth felt the repercussions of the conflict. Stow relates that some French 'pyrates' made an unsuccesful attack on the Isle of Wight and followed it by sailing down the coast to Teignmouth and 'setting fire to the town and burning it up'. It is not clear whether this was East or West Teignmouth. The two villages were still widely separated by the marsh.

East Teignmouth, right by the shore was the more vulnerable, but West Teignmouth, a little inland, was larger and richer.

Soon after this Edward III called 'certain masters of ships' to his Council at Westminster. Teignmouth was one of the towns named. This was not a summons to Parliament – merely to a maritime council to discuss ways of protecting the coast from attacks such as the one by the French 'pyrates'. Two men, Ricus at Will and Willus de Holcombe de Teignmouth attended. Ricus – from near the well – obviously came from West Teignmouth (the well opposite St James'); Willus from Holcombe represented East Teignmouth.

In 1346 the news of the victory at Crecy was greeted with jubilation in Teignmouth (the French were being paid back). A great peal of bells from West Teignmouth Church rang out, including a sounding of the Jesus bell. In the following year Teignmouth, at the king's request, sent 7 ships and 120 men against Calais – which capitulated after a long seige.

In the same year the first deaths were occurring in England from the outbreak of bubonic plague known as the Black Death. The death rate over England as a whole was between 40 and 50%, but the country areas escaped more lightly than the towns. The disease was spread by fleas which had sucked the blood of infected black rats. The rats reached our shores by way of ships trading with southern Europe and the Middle East. No one realised the cause of the plague; various theories were put forward; the most widely accepted was that it was the result of 'bad air'. Pomanders filled with aromatic herbs and spices were carried to purify the air, but the fleas kept on biting and the plague kept on spreading. In Teignmouth hardly a home was untouched. Bishop Grandisson himself, who moved to Bishopsteignton as soon as the epidemic reached Exeter, lost two sisters and several nephews. In Dawlish three vicars died between 1346 and 1349. After the death of the fourth vicar the living remained empty; this, of course, meant that there were no services at St Michael's.

It has been estimated that the death toll in Devon was as high as 48%. Perhaps it was as an act of pious thanksgiving for his own deliverance that Bishop Grandisson rebuilt and enlarged the old palace at Bishopsteignton, converting it into a hospital for the clergy. It was, however, little used and soon fell into decay. The bishop also obtained a Papal Bull to enable him to build a chapel at Old Walls deicated to St John the Evangelist. The vicar of Bishopsteignton Church was ordered to officiate there once a week. This chapel was destroyed in the eighteenth century by Thomas Whidbourne of Ashill who used the stone to build his own house.

The Black Death sounded the funeral knell of the feudal system. No longer were there enough serfs and villeins to plough the fields and tend the herds. Lords of the manor everywhere were offering inducements in the form of cash to those who worked for them. Bonds were ignored. Labourers demanded as

much as 6d per week to harvest grain or cut hay. Even so their standard of living deteriorated. Where before they had been protected by their lords who from self interest if nothing else would not let a workman starve, now they must fend for themselves.

In 1381, hardships suffered as the result of the dislocation of trade and industry by the plague epidemic brought about the Peasants' Revolt. The immediate cause of the rebellion was the introduction of the Poll Tax – another means of extorting money from people already hard-pressed. The

The fish store (later the Bridewell) at bottom of Willow Street

33

revolt had no repercussions in Devon, but it shows how miserable the people of England were at that time and it is obvious that there was much discontent and unhappiness in Teignmouth. The population already decimated by the Black Death continued to decline as people moved away. The salt pans were untended for lack of labour; the harbour was allowed to silt up and the sea defences were neglected.

In 1376 part of East Teignmouth had been acquired by the powerful Courtenay family, possibly for services rendered to the church. They renamed it Teignmouth Courtenay and held it as Puisne Lords under the Dean and Chapter of Exeter who were Lords Paramount. The Church was beginning to relax its hold on the town and on the common people. In 1373 the Bible had been translated into English. No longer was a man dependent on someone else for a translation of Bible stories.

In 1432 a sloop from Teignmouth was seized and sold in Brittany. Since the Hundred Years' War still dragged on this could not be described as an act of piracy and the Teignmouth owners had no redress.

In 1434 a ship, the *John* of Teignmouth left the harbour with 30 pilgrims on board. The captain was Richard Lindsay. The pilgrimage was from West Teignmouth to St James de Compostella – the chief seat of the Order of St James. The badge of the pilgrims was a scallop shell worn on hat or cloak because St James' Day had once been the time when oysters came into season. The pilgrimage was said by the Pope to equal that to Jerusalem. No doubt it was instigated at this time to earn God's blessing on a town which had suffered so grievously.

The fifteenth century ended with an event which, although it made little impact on the town at the time, was to have enormous influence on its future. In 1497 John Cabot discovered Newfoundland, and quite soon afterwards intrepid seamen discovered how rich the Grand Banks were in cod.

4 FROM TUDORS TO STUARTS

Henry VIII, never too sure that his break with the Roman Catholic Church might not lead to an invasion either by the French or the Spanish, was very careful of his coastal defences. To this end, early in his reign, he caused a set of maps to be made which detailed the condition of the south, the most vulnerable, coast. In 1512 an Act was passed which provided for the making of bulwarks along the coast 'wherever the Frenchmen, our auncient enemies,' were likely to land. There were to be 'braies, walls, diches, and al other fortifications from Plymouth westwards to Landes End and by the sea coastes Estwards.' These bulwarks were to be built at the expense of the counties concerned, without any compensation and by forced labour.

From later correspondence it seems that Teignmouth was one of the towns required to make the defences. After the trials of the previous century this must have been a heavy burden on the town – all the labour had to be provided by the townsfolk who would therefore be deprived of the time to gain their normal livelihood. The bulwarks went up, but were carelessly maintained and a century later, in 1628, the town was called to book for neglecting its duty. There was a later Act in Henry VIII's reign which was concerned with 'the amendinge and mayntenance of havens and portes of Plymouth, Dartmouth, Teynmouth, Falmouth and Fowey in the Counties of Devon and Cornwall.'

This was an attempt to control the activities of the Dartmoor tinners whose habit of 'streaming' for tin caused an enormous amount of silt to pour down the rivers and so to block up the esturies. The Act says:

> These portes for some past the principal and most commodious havens and portes within the realm, shipes resorting from all parts of the world

as well as in perill and stormes Which said portes and havens have at this time ben utterly destroyed by means of certain Tynne works, called Streme works ... which personnes more regarding their own private luck than the common good of this realm, have ... so filled and choked the same that whereas before this tyme a ship of portage of 8 hundred might easily have entered at low water ... now a shipe of a hundred can scarecely enter at half fludde

The Act appears to have been in response to a petition for assistance made by the townspeople of the places mentioned. As a result, the tinners were forbidden to work stream-works without sufficient hatches and ties under a penalty of £10. The port concerned was to receive half this money while the remainder went to the Crown.

It may be that the sea defences built against the French had caused an increase in the size of the sandbar at the mouth of the Teign and this had been further aggravated by debris brought down the river which had been trapped between the bar and the land. To this day the size of the sandbanks at the mouth of the Teign fluctuates enormously. On the other hand, without adequate barriers against the sea, the low-lying ground behind the sandbanks would have been quickly inundated. No matter what they cost in time and labour the sea defences needed in the sixteenth century were vitally necessary to the survival of the town. They are just as necessary today.

In 1533, Leland, a chaplain to Henry VIII, was appointed King's Antiquary and in his new capacity set off on a tour of the country; he has this to say of Teignmouth:

The very utter West Point of the land at the mouth of the Teigne is caullid the Ness, and is very high, red cliffe grounde. The Est point of the haven is caullid the Poles. This is low sandy grounde either cast up by the spring of sands out of the Teigne, or els throwen up from the shore by the rage of wynd and water, and this sand now occupieth a great quantity of grounde between Teighnmouth town where the grounde mounteth, and Teignmouth Haven.

There be two towns at this point of the Haven by the name of Teignemouth, one hard joining by the other: the southern of them is Teignemouth Regis, where there is a market and the church of St Michael, and a piece of embattled waul against the shore, and is is taken for the elder town, and at the west side of the town is a piece of sandy ground afore spoken of caullid the Deane, whereon hath been, not many years since, diverse houses and wine cellars.

The inhabitants there tell how their town hath been defaced by the Danes and of late by the Frenchmen.

The other town, caullid Teignemouth Episcopi, standeth by the north on the same shore. There is the church of S. Jacobi.

Some points worth noticing: the Den seems to have continued into Pole Sands; this could well have been so. East Teignmouth was built nearer the sea than West Teignmouth. The latter clustered around St James' church. The name Teignmouth Regis was never applied to East Teignmouth which at this time belonged to the Courtenay family under the Dean and Chapter of Exeter. It had never belonged to the king. The wine cellars mentioned as having stood in East Teignmouth may really have been fish stores – referred to by the locals as 'cellars' (which they were) – used for storing fish. The remains of some rock buildings can occasionally be seen at very low spring tides, just off St Michael's Church. Traditionally there were also cottages just beyond the church.

In 1549 King Edward VI ordered Bishop Vesey 'to give and to grant to Sir Andrew Dudley, Knight, the manors of Bishopsteignton, Radway and West Teignmouth and the advowsons of the vicarage there in the countie of Devon belonging and pertaining to the bishopric.' Now both towns of Teignmouth were out of the hands of the Church. Dudley came into favour in this way: in 1536 Sir Edward Seymour, brother to Henry VIII's wife, Jane Seymour, held the above mentioned manors under the Church. He later became Duke of Somerset. As a result of the Prayer Book Rebellion of 1549 (in which the men of Devon rebelled against the compulsory use of a Prayer Book translated into English) Somerset lost royal favour whereas Dudley, who had acted against the rebels, was rewarded. Somerset was executed in 1551. By then his sister, Jane Seymour, was long dead and Henry VIII had married again. Andrew Dudley was brother to John Dudley, created Duke of Northumberland in 1550 whose second son was married to Lady Jane Grey. He too was later executed after the demise of Jane Grey, but in the year 1549 he was in high favour.

Some two year later, in 1551, Bishopsteignton passed into the hands of Richard Duke who was descended from William Duke, mayor of Exeter 1460. In 1556 Duke became a tenant under the Crown. Bishopsteignton and the other property passed through various hands to the Cecil family in 1608. West Teignmouth which was still considered part of the Manor of Bishopsteignton, underwent all the above changes of ownership.

During the Prayer Book Rebellion, John Newcombe, tinner of Teignmouth, rendered great service to the City of Exeter by discovering a mine dug by the beseigers.

Thomas Coleshill's Revenue List (1549) states that Teignmouth had five ships under 100 tons, the largest being 40 tons. In the preceding years West Teignmouth had continued to move steadily away from Bishopsteignton and

to establish its own identity. The deciding factor in the growth of West Teignmouth was its fishing industry. Since good fishing had been discovered on the Grand Banks, hardy Devon fishermen in their little boats of sometimes only 20 or 30 tons had braved the North Atlantic to fish off Newfoundland. Almost six months of the year were spent there by the men of Dawlish, Kenton, Teignmouth, Newton Abbot and many other Devon towns. Dr Prowse reports that the coast of Newfoundland was 'only half ruled in a rough way by the reckless valour of Devonshire men, half pirates, half traders.' The boats left their home port as soon as the weather had settled, usually in late spring. They carried with them a cargo of goods for those who had emigrated to Newfoundland. Many of them had second wives and families out there, and to this day surnames that are common in Teignmouth can also be found on the island. In the list of ships for the Port of Exeter (which included Teignmouth) the following entries may be found:

> 1583, September 11th. *Elizabeth*, Teignmouth, 20 tons. Thomas Pike owner and master.
> 1583, September 11th. *John*, Teignmouth, 20 tons. Elizens Servye master and owner.
> 1589, August 18th. *Mary Grace*, Teignmouth, 40 tons. Mighell Rowe master and owner.
> 1589, August 28th. *John*, Teignmouth, 30 tons. Thomas Starr owner and master.
> 1593, August 30th. *Jesus*, Teignmouth, 30 tons. William Michalls, of Teignmouth.
> 1593, September 14th. *Paul*, Teignmouth, 45 tons. Thomas Ffoxe
> 1594, August 30th. *John*, Teignmouth, 30 tons. Mighell Rowe owner and master.
> 1594, *Paule*, Teignmouth, 45 tons. Thomas Ffoxe owner and master.
> 1600, September 26th. *John*, Teignmouth, 30 tons. William Braddon owner and master.

French and Spanish fishermen also fished the Grand Banks and it is in the nature of things that a keen rivalry grew up between them. There were frequent fights. Many men were 'lost overboard'. In 1578 there were 50 ships from the West Country in Newfoundland waters, with 150 French vessels, 50 Portuguese and 100 Spanish. Although the West Countrymen were heavily outnumbered they appear to have held their own. In 1585 the Spanish sent no boats to Newfoundland: they were busy preparing the Armada. English boats, however, went out in increasing numbers until the end of the century.

Fishing and fish trading were indeed the mainstays of Teignmouth, and many fortunes were made. Always at the end of the season when the boats

returned home there was a rush to be first in port: the successful ship could command the highest prices for its cargo of dried and salted cod. The fish was stored in a warehouse at the bottom of Willow Street on the Old Quay. The big, red sandstone building, recently refaced with cement and many times renovated, still stands. Its front is Pike Ward's offices. From thence the cod was transported by horse and cart to wherever it was needed. 'Toe rag', as the product was called even to this day was almost a staple food in Devon during the long winter months when fresh meat was scarce.

Its name came about in this way: the Devon farm workers and countrymen in general, unable to afford fitting shoes, wound rag around their feet to ease them in boots which were often several sizes too big. As the rag grew filthy some of the outer layers were removed – the bulk of the bandage stayed in place for some months. When the last of the rag was insufficient to fulfil its purpose it was removed and usually wound round the feet of the children. By this time it was rather smelly – the smell being similar to the smell of salt dried cod, which was affectionately called 'toe rag'. 'Toe rag' was eaten in Teignmouth up to the beginning of World War II and very tasty it was.

The life of the fisherman was, as always, extremely hard. Many men died of disease or were claimed by the sea. The women who remained at home had to grow what food they could to feed themselves and their children. They also collected mussels and other shellfish and even fished from the shore. The women of families who prospered wore fine gowns; others went barefoot. Some ship owners were rich enough to buy themselves land and build good stone houses; others lived in hovels.

The dissolution of the monasteries and the parcelling out of church estates meant that more land was available and many landlords were willing to sell small plots, or even to rent out property on leases of three lives, or 99 years. In both the Teignmouths many houses were privately owned.

New lands were being discovered overseas: it was a time of opportunity. The sharp division between the upper classes and the working man was becoming less so; a new merchant class was coming into existence. Teignmouth must have buzzed with stories of Drake, Gilbert, Hawkins and all the other Devon men who made their names as explorers and adventurers in the sixteenth century. It may be that some local men sailed in their ships.

In July 1588 the Spanish, who had been threatening invasion of these islands, sent their Armada against England. The beacon fires blazed all the way up the Channel coasts. Beacon Hill in Bishopsteignton, (formerly called Gibbet Hill from the gallows which stood there), Beacon Hill in Shaldon and Telegraph Hill on the way to Exeter all had their blazing fires. Local people climbed the cliffs to watch as the Spaniards sailed in their pride up the English Channel, and how great must have been the rejoicing when news of the dispersal and defeat of the enemy fleet came through. It is said that there is

the wreck of a Spanish galleon off Teignmouth. One of its guns was salvaged for the Armada quatercentennial celebrations in 1988.

With the Spanish threat ended there was little to impede the prosperity of the country and of Teignmouth. The Chapel of St Mary Magdalene was partly rebuilt by public subscription. Risdon mentions it in 1630 as 'the hospital which they call Maudlin, which is the pious work of the inhabitants of West Teignmouth'. There were also many bequests for the upkeep of the poor. As early as 1528 Pennyacre Farm, later known as Lower Brimley Farm, was bequeathed to the feoffees of All Hallows, Goldsmith Street, Exeter for the 'upkeep of the fabric [of the church] and of the poor of Teignmouth.' The church became defunct and the parish was diminished in 1919. The dairy farm was sold by Warren Bros, of Exeter. The considerable proceeds were used to alleviate the lot of certain poor families. The farm building now converted into dwellings still stands in Lower Brimley Road.

In 1614 the Cecils sold Bishopsteignton, West Teignmouth and Lindridge to Richard Martyn for £2,900. Martyn claimed descent from Martyn de Tours, a follower of William the Conqueror. He was also a friend of Ben Johnson; *The Poetaster* is dedicated to him. He was rich and well known, a Recorder of the City of London. The property remained in the Martyn family until 1659 when the heiress married Lord Clifford of Chudleigh; later Lindridge and Bishopsteignton passed to the Lear family, Sir John Lear being Sheriff of Devon in 1708 and 1710. Sir John's daughter, Mary, married Thomas Comyns who inherited the estate in 1737.

The property was again split: Lindridge passed to the Finneys, then Baring (1746) and to Sir John Line in 1765. Through marriage it went to the Templers who held it to the end of the nineteenth century. In 1920 it passed to Lord Cable, 1st Baron Ideford and finally to Sir Edward Benthall. Lindridge House was burned down after World War II. Bishopsteignton remained the property of the Comyns but West Teignmouth was held by Lord Clifford until very recent times. In 1671 the Cliffords bought Shaldon from the Carews of Haccombe.

It is interesting to note that, through all the changes, one field in West Teignmouth, at the junction of Fourth Avenue and Mill Lane, remained the property of the Bishops of Exeter. Until after World War II houses built on this land paid ground rent to the Church. The field is marked on Ordnance Surveys as 'Bishop's Field'.

Risdon, writing in 1630, paid some attention to Teignmouth. He says: 'In former times it has been more populous and of better esteem, enjoying many privileges It possessed a prison ... and poor houses.' He also states that East Teignmouth 'claimed anything of value found on the bodies of those drowned between a place called Hackney in the West and the Clerk in the East.' (One of the privileges was exemption from payment of tolls on ships

and merchandise, granted to West Teignmouth in 1309 by Royal Charter).

In 1534 Henry VIII introduced 'Papacy without the Pope'. He denied the Pope's authority – substituting his own – but still persecuted those who rebelled against the Catholic doctrine. This caused a schism in the Church. There was the Catholic Church of England which recognised Henry as head, and the Roman Catholic Church which recognised the authority of the Pope. In England a series of laws were intoduced making Roman Catholicism illegal: these laws were not fully repealed until 1829 although they were relaxed after the middle of the eighteenth century. In Teignmouth Roman Catholics continued to worship in the old way. Their overlords, the Cliffords and the Courtenays, were ardently Catholic, which made things easier.

The Jolly Sailor Inn, built in the early sixteenth century as the Ferry Boat Inn, stood on a patch or rising ground in the estuary of the Tame. From it the ferry plied across the river. The land was called Rat Island because it was cut off from the mainland at high tide and could only be reached by a bridge. The inn still stands. In it is a very old chimney which has hidden many a Catholic priest: the chimney is now disused. In the adjoining room Catholic services were held regularly. The altar and candlesticks were also used at Ugbrooke House, the seat of the Cliffords. They are now in the possession of the Catholic Church, having been donated by a non-catholic Teignmouthian – Mr Pike Ward, in the last century.

The ferry across the river was first mentioned as one of the perquisites of the Earl of Cornwall in the eleventh century. What happened to it later is uncertain. The ford at Passage House Inn, higher up the river, was used by monks and other persons wishing to go to the monastery at Torre. There was also a ford from Bishopsteignton to Coombe Cellars. Both of these were for horse drawn vehicles only, and it seems they silted up. A crossing by boat may always have existed from Teignmouth. Queen Elizabeth I granted the right to run a ferry across the Teign to the Cecil Family when they held the Manor of West Teignmouth in the early seventeenth century. The crossing was 'within the Manor of West Teignmouth' and therefore further up the river than the present one. Salty – the large sandy island in the middle of the Teign – was then much lower if it existed at all.

5 ALARMS AND INCURSIONS

Historically, Teignmouth always feared invasion, remembering the Saxons, the Danes, and the French. In 1625 it seemed to happen again. A number of Flemish ships entered the harbour. A constable took a deposition which reads:

> On the 11th day of June, 1625, the *Fortune,* the *Rosemarie,* the *Margrett and John* and the *Friendship* of Topsham ... did discover 25 saile ... at last the fleete gave us chase ... and they sent a long boat ... about 50 men ... which came very near to us until we could recover Teignmouth Aid then supposing them to be pirates we shotte at them. So there came into Teignmouth ... 4 boats with at least 30 men in each boat armed with musketts and cutleaxes, and we demanded what they woulde and they told us that they woulde have our shippes, so we wished them to forbear to come aboard of our ship, never the less they approached nearer unto us: whereupon we discharged our musketts; they discharged theirs so we still stood upon our guard. They they went ashore and what they did there we know not, so at last they departed thence: we suppose them to be Turks and Hollanders this is as much as we can relate of the business.
>
> There came abord of us one boate and entered only one man: but presently departed seeing our shippe was provided in reasonable manner.
>
> *Signed: Henry Tailler Mr*
> *Peter Wislake*
> *Richard Call, Cappeten*
> *Maurice Levermore, Merchant*

The matter was naturally important to the lord of the manor and Sir George Chudleigh became involved. He took a deposition which was substantially the same as the foregoing, but added one or two details. Only the *Margrett and John* took refuge in Teignmouth. Two other ships, one from Teignmouth and one from St Nicholas came to the rescue of the English boats and helped them to harbour. The Flemings at first seemed friendly. When challenged they said they were the king's friends and meant no harm, but the English did not trust them and opened fire, which the Flemings returned. About 50 men came ashore armed with muskets and swords.

On being questioned they said they were 'Holland Men of War' who went to sea with the English Fleet. They believed that the four English ships were pirates, and demanded to speak to the mayor. No such officer being available they asked to go aboard the English ships in order to satisfy themselves. This was agreed providing that they lay aside their arms. So doing, they attempted to board the *Fortune*, but the English sailors were so aggressive in their attitude that the Flemings desisted and asked again to speak with a responsible officer. At this point Sir George appears to have given up. He told the Flemings that their action had caused the beacons to be fired; 2,000 men would be there within an hour. The Flemings answered: 'Let them cum on in God's name we are the King's friends.' Shortly afterwards they departed. The two lords of the manors sent the depositions to the Privy Council explaining that whatever had been said no damage was done although the Flemings could have rifled the ships and the town. The matter was one of misunderstanding and fear on the part of the British seamen.

In 1628 Teignmouth with other towns was called to book for again neglecting its sea defences. Fifty yards of bulwarks had to be built east of the windmill and 46½ on the west. (The windmill stood midway between the Bella Vista Hotel and the Point). East Teignmouth had to construct 2½ yards, West Teignmouth 7½ yards, Bishopsteignton 11½ yards and the remainder was the responsibility of parishes such as Exminster and Bovey Tracey who shared in the prosperity of Teignmouth and depended on its survival.

At this time West Teignmouth was a maze of small streets around the church with trackways running down to the Tame estuary and the harbour. There was a street parallel to the present Bitton Park Road but nearer the harbour. Saxe Street, now demolished, was the main street. There were cottages at the bottom of Exeter Road and houses by the well opposite the church in Welley (Willey) Lane. Lower Bitton House stood isolated in its many acres at the foot of Bitton Hill. There was a mill nearby. The track ran from St James Church to Lower Bitton House, then north over Headway Cross to Old Walls, or across The Lea to Bishopsteignton village. The present road along the river's edge did not exist: its way was blocked by cliffs which fell sheer to the water's edge just beyond Broadmeadow.

Church Street (Daimond's Lane) consisted of a farm and a few cottages – Church cottages. Nos 5 and 5a Daimond's Lane were the farmhouse. Mrs J Collett of No 5 has deeds relating to the cottages, which go back to the early seventeenth century. In the lower part of the street was the priest's house where the curate visiting from Bishopsteignton sometimes stayed. Behind the church was a well which is mentioned in several documents dating from that century. A path led from St James' across to St Michael's Church, crossing the Tame at its lowest fordable point – near the bottom of the present Lower Brook Street. There was a bridge there from very early times.

East Teignmouth clustered around St Michael's Church, descending to the edge of the marsh at French Street. The market was held on rising ground by the present Bella Vista Hotel and the market cross stood nearby. Where the market was held in West Teignmouth in those early times has never been identified. It was probably in the village of Bishopsteignton. The market cross could be the one which was at Cross house.

The two Teignmouths were still quite separate. Undoubtedly both had suffered in the Civil War. Both had lords of the manor who were Royalists. The Courtenays took a very active part in the struggle and at one time Powderham Castle was forced to surrender to the Roundheads. Again it had been a difficult century – and Teignmouth's troubles were by no means over.

James II left the English throne in 1688 when William of Orange, invited by the British people on account of his Protestant background and his wife's descent from James I, successfully marched on London. William landed at Brixham in November and was proclaimed King of England at Newton Abbot. After spending a night at Forde House he marched on Exeter with incredible pomp. His retinue included horse artillery 200 negroes, war horses, gentlemen, pages, 3,000 Swiss guards in full dress, 600 Guards and 500 Volunteers as well as others. There were over 30,000 persons in the procession. The people of Teignmouth flocked to Haldon, perhaps not to cheer – for many of them were Catholics and so were their overlords – but certainly to stare.

But the crowning of William of Orange was not the end of the matter. James II, who on the advent of William had fled to France, was determined to recover the crown, and the French were willing to assist him. The French fleet joined battle with the English and Dutch on 11 July 1690, and defeated them utterly. But on the following day James himself was defeated at the Battle of the Boyne, in Ireland: his hopes for the success of his venture were completely destroyed.

The French fleet however, flushed with success at their victory over the English and Dutch, sailed down the Channel and came upon Teignmouth. Dawlish, built almost a mile inland behind a marsh, they did not notice, but Teignmouth, with its Church of St Michael almost on the beach, its fine

natural harbourage and its look of prosperity reminded them of the feuds and dissensions endured by their fishermen in Newfoundland waters. They did not like Teignmouthians, so after a few days spent at anchor in Torbay, no doubt enraged by the news of James' defeat, they sailed in and destroyed Teignmouth. The populace, who had been watching them, were warned, and to a man they fled to Haldon from whence they watched as the two villages were pillaged and burned. East Teignmouth was almost totally destroyed. Both churches were ransacked and their registers burned, but no lives lost. The Lysons state that a Mr Errington, curate of West Teignmouth, vanished and was never seen again. He did reappear, however, and is buried in St James' churchyard.

Lord Macaulay describes the reaction to the raid thus:

> The beacon on the ridge above Teignmouth (Haldon) was kindled to warn of the French invasion...Hay Tor and Cawsand answered and soon all the beacons of the West were afire. Messengers rode all night from Deputy Lieutenant to Deputy Lieutenant, and early next morning, without chief, without summons, 500 gentlemen and yeomen, armed and mounted, had assembled on the summit of Haldon Hill. In 24 hours all Devonshire was up.

Such help came too late. Teignmouth was a smoking ruin, and the French had departed.

Hatred of their 'auncient enemies' rose to incredible heights in the town. Witch hunts were carried out to discover French sympathisers. A Frenchman who lived at Labrador Bay was suspected – prudently he left the area somewhat hastily, which confirmed the belief he was a spy.

Bishop Burnet, in his History of His Own Times, was at pains to decry the destruction of Teignmouth, implying that the French were cowards in showing their might against a humble and inoffensive town; the smaller and more inoffensive the town, the greater cowards the French. Accordingly he writes that:

> The French made a descent on a miserable village called Tinmouth, and they burned it and a few fishing boats that belonged to it. But the inhabitants got away, and as a body of Militia were marching there the French made great haste to get back to their ships. The French published this in their gazette with great pomp as if it had been a great trading town that had many ships and some men-of-war in port.
> This both rendered them ridiculous and served to raise the hatred of the nation against them, for every town on the coast saw what they must expect if the French landed.

GOD Save the KING and QUEEN.

The Church Brief of 1690

That Teignmouth was by no means as insignificant as the bishop would have us believe emerges from the fact that the damage done amounted to more than £11,000.

The inhabitants of the two villages sent a petition to the Lord Lieutenant of the County and the Justices of the peace. It ran thus:

> The humble petition of we whose names are subscribed in behalf of ourselves and many others, the poor inhabitants of the severall parishes of East and West Teignmouth and of St Nicholas in the said county.

> Humbly sheweth:-

> That on Saturday the 26th day of this instant July 1690 by four of the clocke in the morning, your poor petitioners were invaded by those barbarous inhuman enemies of our Religion and Country, of the French nation, to the number of 1,000 or thereabouts, who in the space of three houres tyme, burnt down to the ground the dwelling houses of 240 persons of our parishes and upwards, plundered and carried away all our goods, defaced our churches, burnt ten of our shipps in our harbour, besides our fishing boats, netts and other fishing craft, to the utter ruin of your poor petitioners and their families, many of whom must starve from want and perish unless they are speedily relieved by your honours' charitable assistance in this their great extremity ... As in duty bound we shall ever pray.

As a result of the appeal a petition was sent to the Crown stating the damage done to amount to £11,030.6s.10d. The petition was validated by the oaths of William and Roger Rendle, carpenters, Richard Elliot and John Herton, masons, Samuel Smith shipwright and 'divers other creditable persons, inhabitants of the townes and parishes of East and West Teignmouth who have viewed and adjudged the same.' The petition promised that 'noe part of the monys shall be applied to any landlord or other person of ability and the said petitioners nor either of them shall assigne or put over his or her collection to any other.' It was signed Peter Fortescue, John Quick, John Burrington, Peter Beavis, Richard Osborne, John Cloberry, Jno Battershill, Charles Hore, Thomas Reynell, Hugh Stafford, Jno Cholwick and Edward Yard.

The body of the petition was signed by 680 of the inhabitants and forwarded on behalf of East Teignmouth (signed Oliver Manwaring), West Teignmouth (Jo. Bawden), Shaldon (Jo. Rich). After so much supplication it is not surprising that a 'Church Brief' was issued which repeated the complaints of the people of Teignmouth and included several more details

such as 'that from the cannon of their galleys they shot near 200 great shot into the town, that they tore up the Bibles and Prayer Books ... and slew many cattle and hogs which they left lying in the streets.' The Brief urged the clergy to be zealous in collecting money for the charity. It ordered the 'vicars and parsons' to publish the matter on the Sunday following the receipt of the document and asked that congregations should donate freely and cheerfully to raise the sum of £11,000.

The money was to be sent on collection to Jonathan, Bishop of Exeter; Richard Annesly, Dean of Exeter; Sir William Courtenay; Sir Henry Carew; Sir Thomas Lear; Francis Courtenay, Edward Yard, Henry Northleigh; Gilbert Yard and several other worthies who were appointed Commissioners. A quorum was to be responsible for the distribution of the money and Nicholas Cove is specifically mentioned. (He was also one of the Commissioners).

The documents relating to the raid are interesting. They give us some idea of the size of the two towns. (300 houses are mentioned at one point in the Brief. Of these 288 were destroyed.) There were at least 680 inhabitants - they signed the Brief. The Carews, the Lears, the Courtenays emerge among the names of the gentry together with Nicholas Cove.

The Coves lived at Green in Bishopsteignton. They had settled there about 1615 because the Cove initials are carved on a fireplace with that date. The date on the front door is also 1615. Tradition has it that the family came from Exeter where they had lived in a house at the end of Exe Bridge. The bridge was washed away one night by a great flood. John Cove awoke to discover that he and his good lady were drifting down the Exe, still in their four-poster bed. Forbidding his wife to move, John propelled the bed to shore using his hands and feet as paddles. Deciding that life in Exeter was altogether too hazardous the Coves moved to Green at Bishopsteignton, where the family remained for about 300 years.

John Risdon is listed among the gentry appointed as Commissioners of the Brief. He was then living at Lower Bitton House, which, because it was a little way out of Teignmouth, had escaped damage.

Not a great deal is known about the Risdons – which is remarkable since they were one of the leading families in the the district. John was Vicar of Bishopsteignton from 1661 to 1684, and at the time of his appointment to the Commission, was retired. He appears to have purchased Lower Bitton House, formerly the property of the Bishops of Exeter. His son, William, followed him as Vicar of Bishopsteignton (1684-1685) when he died – possibly of the plague – at the age of 29 years. His epitaph in Bishopsteignton church reads:

Of a sickness loe here he lies
Cut down by death in the midst of his dayes

John's elder son, Richard, was drowned whilst fishing in Newfoundland waters. Another son, Nicholas, married and lived at Lower Bitton House until his death in 1712, aged 52 years. His wife, Mary, survived until 1718. The family were obviously closely connected with the Church. Tristram, the topographer, was a relative, even perhaps a cousin. The Risdons are first noted at Winscot St Giles, near Great Torrington, in the sixteenth century and Tristram was born there. Risdon Farm, however, is near Okehampton and that may have been their original home. Tristram married an Exeter girl, Pasha Chaffe and had some connection with the Halls, one of whom was Bishop of Exeter in 1627. It may be that Bishop Hall used Lower Bitton House as a summer retreat and that the Risdons settled there through his influence. The estate was large and extended from Bitton Brook in the west to Clay Lane in the east. The Risdons' tombs are in Bishopsteignton churchyard. The family arms were: Sable 3 birds, bolts argent.

About the end of the seventeenth century a large house was built on Risdon lands just off Bitton Park Road, between the present Bitton Avenue and the road. It was called Teignmouth House (not to be confused with the present Teignmouth House, 25 Teign Street). In the eighteenth century Teignmouth House was the home of the Hall family.

The seventeenth had indeed been a black century for Teignmouth. Prosperity had declined as a result of the Civil War, the plague of 1665/66 caused many deaths in the town. (In Bishopsteignton churchyard, down by the wall, are some iron-bound tombs said to be those of plague victims). Finally the town had been devastated by the French, the inhabitants only preserving those goods they could carry away with them.

As a last blow the salt works closed down. It was cheaper and easier to scoop salt out of the ground in Cheshire than to make it from sea water in places like Teignmouth. In 1692, Mary Wilkinson, the last salt maker, gave up her trade. She too, had had her tribulations. Originally the main channel of the Tame had flowed much further east than it did in the late seventeenth century and Mary had salt 'pavements' (artificially raised ground over the marsh) along the line of the present Osmond's Lane. Then, perhaps as the result of a great storm, the channel moved further west, and Mary was forced to lease a new parcel of ground near the fresh water essential to her trade. What with one thing and another it was probably all too much for her, and she was an old lady. Her retirement marked the end of an era.

6 THE MODERN TOWN

Teignmouth had to be rebuilt, and quickly. The homeless needed houses, business premises were required, boats, nets and fishing-gear all needed replacement if the life of the town was to continue. Some things could never be replaced; the church registers could never be duplicated. A group of golden herrings which had hung in St Michael's church, a votive offering from fishermen, was lost forever.

Timber buildings were hastily thrown up between 1690 and 1700, and thereafter traditional houses, some on lath and plaster frames were constructed. At this time the Tame had been partially channelled and much of the marsh had been raised by throwing over it the ballast from ships which came into the port empty but left laden; it is said that the centre of Teignmouth is built on rocks from foreign shores.

A wall had been built across the lower channel of the Tame to keep the tide out and the eastern end of Rat Island was joined to the beachy mud and rocks which led to the Den. The centre of Teignmouth was still flooded at high tide and the Great Marsh extended from Station Road up through Lower Brimley. There was a patch of marsh between Dawlish Road and French Street, and Frog Marsh filled the upper part of Lower Brook Street. At the top of the street, by the station, there was a bridge over the Tame and a deep pool, used for washing sheep. At the other end of the street the Long Bridge extended from Lower Brook Street over to Holland's Road. A pool here was used for floating timber.

It was dry enough to build in Bank Street and Wellington Street and along the higher side of Teign Street, but even so Teignmouth was still clearly divided in two by the course of the Tame. When Hitchen's shop in

Wellington Street was being refurbished some years ago, the remains of a wooden structure built about 1690 could clearly be seen in the foundations together with part of a charred beam.

Familiar names were appearing on documents written in the late seventeenth century. A family of tradespeople – carpenters and coachbuilders – had established themselves in East Teignmouth in the early 1600s: the Jordans. The Drews and Boynes were living in West Teignmouth.

The Tapleys were a Bishopsteignton family – farmers and mariners – who moved to Teignmouth in the latter part of the seventeenth century and took up fishing, a trade which was eked out by a little smuggling and privateering. Hugh Tapley, who died at Bishopsteignton on 21 December, 1587, is recorded as leaving eight sheep worth 16 shillings, wearing apparel 10 shillings and money to the value of 40 shillings, so the family were fairly well-to-do. (Hugh must have been unmarried since no household chattles are mentioned). The family had a house in Teignmouth, roughly where Lloyd's Bank now stands. The grounds of Tapley Cottage, which remains to this day in the street behind, bordered an area known as Frog Marsh in the upper estuary of the Tame.

Mr William Tapley of Perranarworthal, Cornwall, gives some details of the later activities of the family in notes dating from about 1811, supplied by his great uncle:

> The writer of this true story was the elder son of a Gentleman of some independent means and owning some land and some houses in the South West of England. The wars with France during Napoleon Bonaparte's reign were engaging Great Britain both on land and sea. The town of Teignmouth had been attacked (some years previously) and a party landed there. The residence of Mr Tapley had been set fire with others.
>
> The old houses however, having many of the walls built of great thickness, some being 6ft through and very large stones being used, were not easily burned down and the thick beams resisted the fires. These houses being pulled down about a hundred years afterwards revealed some of the beams in a charred state in which the fire had left them
>
> As money was to be made quickly by merchant ships during Napoleonic Wars, Mr Tapley sold some of his land and had a ship built in which his son sailed as captain. He sailed with a convoy to Hong Kong and returning with a valuable cargo, falling behind, was taken by a French brig. The ship was stripped of any easily taken valuables, and then burnt before the eyes of the captain and crew who were all taken prisoner and lodged in French prisons.

Mr Langley [of Teignmouth] on the march [to prison] seeing the prisoners chained in twos and himself an odd one, hoped to escape ... but he was chained to a horse – much to his disgust

They determined to escape, but as Mr Langley had a wife and children at home in Teignmouth, they would not take him with them, saying that they, being unmarried would risk their lives since an order to shoot all who attempted to escape had been given. They would not take any married man with them.

Mr Langley was afterwards more rigorously confined since the French believed that he had helped the others with their plans to escape He regained his liberty after the Battle of Waterloo.

Mr William Tapley's great-uncle's notes included a handwritten account of the escape of the Devon men and the vicissitudes they endured, their joy at obtaining a passage to England and being 'kitted out' by a friendly seaman from Shaldon, called Davis. They finally arrived in Exeter where they 'took a glass of grog and set out on foot for their homes.'

The last privateer to sail out of Teignmouth, not long before Waterloo, was captained by a Tapley. Both the Tapleys and Langleys survived in Teignmouth until the twentieth century. In 1759 Mr William Langley leased 'Houses, cellars and courtledges with a garden plot on Rat Island.' The houses have gone but some old walls and windows remain on the Somerset Place side of the Jolly Sailor Inn.

Another familiar name cropping up about this time is that of Shimell. The family came over from Holland with William of Orange and settled in the town becoming coachman and housekeeper to the Risdons of Lower Bitton. After the death of Mrs Risdon in 1718 they moved into fishing and building work. One of the family married a Burden who built the Bella Vista hotel about 1800, then called Den Beach Hotel. Mrs Mary Risdon left the estate, on her death, 'for the poor of Teignmouth who received no other relief.' The charity still exists In 1771 the property was leased by Mr Morgan, but whether he was the first lessee is not known.

Prosperity came to Teignmouth in the eighteenth century. Both towns grew. In 1730 sea-bathing became popular off the coast of East Yorkshire. The fact that the bathers were nude caused little comment, but it was noticed that they were hardier than those who did not dip themselves in sea water. Within a few years sea bathing became fashionable. The fortunes of the south coast towns with their mild climate and warmer sea water were assured, but it was not until the latter part of the century that Teignmouth began to benefit.

There is no record of the amount of money raised by the Brief of 1690 for the rebuilding of Teignmouth and the care of its inhabitants. French Street was erected certainly – a plaque on its wall commemorates the event. Off

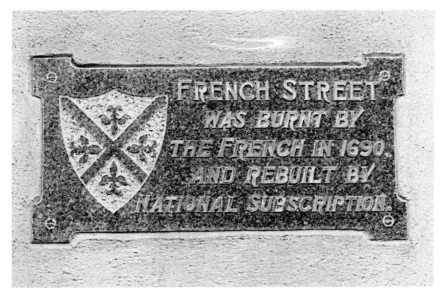

The plaque recording French raid of 1690, at end of French Street

French Street, until just after World War 2 there was a small terrace, Terra Nova Place, which bore the date 1730. The terrace is now demolished. The cottages at the bottom of Dawlish Street also date from about this time. Being so near St Michael's Church the site undoubtedly suffered in the French raid. Some better class houses in Carlton Place – on lath and plaster frames (now demolished to make way for the Police Station and Magistrates' Court) – were, no doubt, built for better-off people.

East Teignmouth still belonged to the Courtenay family. The western corner of the Den which in the thirteenth century belonged to the Earl of Cornwall and is listed among his possessions at the time of his death was, in the seventeenth century, part of the Manor of Kenton and belonged to Lord Grenville. The windmill marked the boundary between Kenton and East Teignmouth. In 1712 Sir William Countenay purchased this land together with the harbour dues. The sale also included some houses in West Teignmouth 'near the church'. From Mrs Collett's deeds it appears that some land in Daimond's Lane belonged to the Manor of Kenton so the houses were probably located there. 'Tonmouthe Passag' which is how the land at the Point is described in the will of Edmund, Earl of Cornwall, must have been the original ferry crossing known to be part of the perquisites in the hands of the Earls of Cornwall in the eleventh century. It is very tempting to link them with the incident described in the Chronicles of both Wace and Layamon.

However, in 1712 the ferry rights were in the hands of Lord Clifford and firmly established in the Manor of West Teignmouth.

After the Revocation of the Edict of Nantes in 1685 by which French Protestants lost their freedom of worship many Huguenots fled to England and some settled in the West Country. With Protestant William on the throne they felt safe. Tradition has it that some of the larger houses on the outskirts of Teignmouth were built by these well-off Frenchmen and where deeds have survived this is indeed the case.

Map of Teignmouth and Shaldon 1741 showing indented estuary of the Tame

In West Teignmouth a small haven at the mouth of the Tame was used by local inshore fishermen to berth their boats. There they sat to mend their nets and exchange gossip. At the bottom of Scown's Lane, which abutted on this area, quantities of broken clay pipes have been found, dropped by the men as they sat. A penny dated 1740 was found by Mr David Leggatt, forced into the roof beams of a house in the Lane – perhaps for good luck. Under the floor in 34 Teign Street, on the corner of Scown's Lane, the ripples of an ancient tide can still be seen in the sandy foundations and next door the skeleton of a wooden boat was discovered under the living room floor. This area was reclaimed from the Tame estuary early in the eighteenth century.

West Teignmouth was growing fast. Clay was being exported from the Teign valley: the first shipment left Teignmouth in 1700. In the previous

54

century it had been carried on horseback from pits in the Bovey Basin to Exeter or Topsham. Now it travelled by horse-drawn barge to a depository at Hackney from whence it came down-river. Wool was also exported from West Teignmouth. The Devonshire woollen trade was thriving and the weavers of Newton Bushell (Newton Abbot) were busy. Many laws had been passed to encourage the wool trade; one ensured that everyone wore a woollen cap (sixteenth century), and another burial in a woollen shroud. Woven cloth was exported from Teignmouth to the Continent together with an appreciable amount of raw wool. At the close of the seventeenth century the export of salt had come to an end (it had formerly been sent to Newfoundland for the curing of fish). Instead it had to be imported from Cheshire for the use of Devon people. Smuggling was still rife – it always had been – but privateering ended at the close of the Napoleonic Wars.

The Fort on the Den, 1744

The French threat worried Teignmouthians. In 1744 they petitioned Sir William Courtenay to allow them to erect at their own expense, a small battery in East Teignmouth – the more vulnerable parish. The fort was built near the present lighthouse by the Den, by a small hillock, called Dogges Hill, shown on the map of 1771. Formerly it was believed that the fort was by the Bella Vista Hotel. That was, in fact, the site of a small battery hence its name: the

Gun. The Lords of the Admiralty supplied small arms, cannon and ammunition for the fort which was still in existence in 1800.

Both parishes were holding markets and fairs. On the map of 1759 the market cross of East Teignmouth is shown on the rising ground east of the Triangle. Sheep were grazed on the Den which, where it was dry enough, produced a plentiful wiry grass. On the site of the present Dawlish Inn stood a hostelry called the Seven Stars.

In West Teignmouth the market was held in Teign Street on the site of the present Ernest Shimell's yard. Some of the old structures remain. In later years, after the building of the new market in the nineteenth century, this yard became Sharam's coachbuilding premises. The hoist remains and the upper walls are streaked with paint where the workmen wiped their brushes. As a result of the eighteenth century situation of the market Teign Street was then called Market Street.

From 1660 until 1815 both churches were served by one curate who lived in the Priest's House in Daimond's Lane. The gift of each living was in the hands of Dawlish and Bishopsteignton.

About 1750 there came the first hint of plans to reclaim the centre of Teignmouth – to drain the whole marsh. It was a formidable task as there were so many sources of water. A deep ditch ran down the middle of Dawlish Road – the Litterbourne, renowned for its filthiness. It turned sharply east to empty into the sea just above St Michael's church. The exit is still used for drainage. It was crossed by a bridge at the top of the present Mere Lane. At the bottom of Dawlish Road the Great Marsh covered Regent Gardens to Lower Brook Street. The great marsh ran up the Brimley Valley. The Triangle, Waterloo Street and Brunswick were beachy mud flooded at high tide. The Tame flowed into the Teign by way of the Little Triangle, Somerset Place and Gale's Hill. It was considered that a wall might be built across Rat Island to keep out the tide and that the Tame might be confined to one channel debouching from Gale's Hill. Meanwhile the marsh could be raised and drained by the use of ballast and ditches.

With all its disadvantages the town was thought to be very healthy. In the Grand Gazeteer of 1759 there is this entry:

> Teignmouth has of late been beautified with diverse handsome and delightful buildings, the air being very wholesome here, especially in the summer season, whereof it is visited both for health and recreation. It has a good share of the Newfoundland Trade and a pretty good fishery of its own.

The Royal Magazine 1762 says: 'The inhabitants live to a good old age and one, Bawden, of East Teignmouth, recently deceased, lived to the age of 106,

who never had a tooth drawn, nor knew what pain was.' The same magazine mentions 2 churches but says there were 'no other meetings'. The two parishes contained between 300 and 400 houses, 'empty houses being very uncommon'. The article states that the men of Teignmouth worked mostly in the Newfoundland trade, while the women gathered shellfish and spun 'jadoo' thread, Teignmouth thread, for which the town became famous. Two bathing machines had recently been constructed and people came from all parts to drink the sea water. There had been miraculous cures, cripples could walk, lepers were made whole, a paralyzed man was cured after bathing and drinking the water. The principal promenade (the Den) was a pleasant place covered with wild thyme. Finally: 'it is hoped that the great resort of strangers will induce the inhabitants to make their houses more commodious.' Perhaps something was done. In a letter to the Gentleman's Magazine, 1793, the Rev. John Swete of Oxton House says 'Its houses are palaces, its inns are good if not superior to any other place of summer resort in Devon. The bustle and importance to its commerce attract attention.'

The commerce to which the reverend gentleman referred was no doubt the business of the port. In 1740, 500 tons of clay had been exported. By 1785 this had risen to 9,995 tons. In 1790 James Templer had begun constructing the Stover Canal which allowed clay to be transported by horse-drawn barges to the head of the Teign estuary. This was an enormous boost to the clay trade and so to Teignmouth.

In the months of July, August and September, 1773, Fanny Burney, the diarist, stayed in the town as the guest of her sister, Martha Rishton. The cottage in which she stayed belonged to a sea captain, and the front looked out on a fine green 'not a quarter of a mile from the ocean.' It contained a parlour furnished with china, glass and flowers, and a scullery converted into a kitchen. Over this were two bedrooms with 'nice clean linen beds.' Miss Burney tells us that the 'rural beauties of this place become every year more known in so much as the price of all provisions is actually doubled in these last three years.'

She describes in some detail the life of the town. There were donkey races on the Den; once there was an ass race in which 16 donkeys took part, and a pig race. She mentions that cricket was played on the Den and that there were wrestling matches. She saw a rowing race between the women of Shaldon in which five boats took part. She noted that the lives of the women of the town were not all play:

> You see here nothing but women all Summer – their husbands go out
> to the Newfoundland fishery for eight or nine months of the year
> The women of Teignmouth have a strength and hardness which I have
> never before seen in our race The women of the town do all the

> laborious business such as the rowing and towing of boats, and go out fishing Yet I never saw cleaner cottages nor healthier, finer children.

She watched women line-fishing from the beach and says of them:

> Their dress is barbarous. They have stays half-laced and something by way of a kerchief about their necks. They wear one coloured flannel or stuff petticoat; no shoes or stockings, notwithstanding the hard pebbles and stones all along the beach; their coat is pinned up in the shape of a pair of tousers leaving them wholly naked to the knee.

The donkeys used in races for the entertainment of visitors were commonly seen in the town since they were the usual means of carrying goods, either on donkey-back or in panniers. The pigs were also a common sight: there was one in every back garden to provide lard and bacon throughout the winter.

7 THE LETTERBOOK OF A BUSINESSMAN

With the outbreak of the American War of Independence in 1775 and the involvement of France and Spain in 1778. Teignmouth again suffered at the hands of foreigners. The Americans had built up a strong force of privateers and many Teignmouth fishing boats were captured by them off the Grand Banks. Familiar names again occur among the local seafaring men: Langley, Rendell, Pike, Whiteway, Perryman, Tapley, and Sharland. Mrs Ellen Brook of 17 Somerset Place whose mother was a Perryman has an interesting scrapbook about her seafaring forebears.

When the French invaded Teignmouth in 1690 they destroyed a building standing in its own grounds, just above the marsh on the site of the present Woolworth's Stores. This had been used as the local bank. In 1785 James, Jardine and Dickson re-established a money-lending and banking business there and in 1808 the premises were sold to Langmead, Holland and Jordan, and was known as the Teignmouth Bank. The firm issued its own notes and was looked on as a prestigious local institution. The street which was built alongside the bank is still called Bank Street. In 1837 the business again changed hands passing to Watts, Whidmore and Co. It was taken over by the Capital and Counties Bank in 1891, finally being absorbed into Lloyd's bank in 1918. The building itself then became a sales point for motor vehicles, after which it was taken over by Woolworth's.

The notes issued by Holland Langmead, Jordan and Co. have a distinct local flavour. The engraving shows the mouth of the Teign looking towards the Ness, with a small sailing boat entering the open sea. A fishing boat is being hauled by two men and two more are looking out to sea.

One of the partners in the bank Robert Jordan probably did more for Teignmouth than any other one man, although it must be admitted that at the same time he made himself very wealthy. His activities were many and varied.

In 1798 he bought a sloop, the Racehorse, from a vendor in Falmouth. Very shortly it was wrecked, but Jordan had it repaired and used it in the coasting trade, carrying clay, coal and other goods. The sloop is mentioned in one of the following letters which in themselves give a fair view of Robert Jordan's business acumen and activities. They are taken from the copies in his letterbook:

[1] *2nd January, 1792. To Sir James Wright.*
... the rent of Bitton House, lately leased to Mr Wm Praed deceased, has according to the terms of Mrs Risdon's will been distributed to the poor of West Teignmouth who receive no poor relief This last autumn was very tempestuous and several vessels belonging to the place were lost and nearly twenty of the mariners of the town have lost their lives
Among the visitors to this place last summer were the Duke and Duchess of Somerset, Duke and Duchess of Beaufort, three Ladies Somerset and Lord and Lady Falmouth, Lord and Lady Tracey. One family only winters here Many depredations have been committed in Teignmouth lately and several houses broken into and robbed
Polwhele's *History of Devonshire*, so long and eagerly awaited has not made its appearance yet. The first volume, however, will be published soon

[2] *2nd October 1792. To Messrs Trewman.*
This morning about half after seven o'clock a fine new ship belonging to Mr Robert Stevenson of London, Turkey Merchant and Capt. R. Brine of this place was launched at Ringmore in this River. In compliment to Mr Stevenson's daughter she was named *Sophia* and is perhaps as complete a vessel as any that was launched from a private yard. She was built by Mr John Stevens whose great ingenuity in Naval architecture has gained him the greatest reputation. The morning although overcast with clouds, was mild and serene which with the number of boats filled with gentry on the river and the numerous assemblage of spectators on the neighbouring hills, added greatly to the beauty of the spectacle. Though several families have quitted this place yet it is still lively and gay and, as many houses are taken for the winter months, it will continue to be cheerful. The new walk is quite completed but on account of the late perpetual rains it has been little frequented. The poor man who was drowned in the boat which overset off this place about a fortnight since, has been taken up and after an inquest held on his body by the coroner, buried in East Teignmouth churchyard.

[3] *28th January 1973. To Sir James Wright.*
[He encloses a resolution of the Loyal Teignmouth Association of a petition to be handed to the Duke of Richmond to request him] 'to grant us in case of war with the French, ordnance and supplies for the fort ...' It was also decided that it was highly necessary to repair and fortify the fort to repel attacks of the smaller privateers which may hover on the coast for the purpose of making descents on those small places that are unguarded and defenceless.
[The petition mentioned was signed by gentlemen, clergy, merchants and freeholders of Teignmouth and by the merchants of Shaldon and Ringmore. Sir James Wright was asked to hand it to His Grace. Jordan ends:]
I cannot conclude without condoling with you on the late bloody murder of the King of France by the Convention. The enormity of this crime ought to rouse every Englishman to vengeance. May Heaven revenge the bloody deed. Riots prevail much in Cornwall and at this moment there are 300 men in Teignmouth from Newton to seize a sloop laden with barley bound for Poole. Their pretence for these proceedings is that she is bound for France. I hope to God that no mischief will ensue At present they behave very peaceable. Their conduct, nevertheless, is very unjustifiable.
[He also suggested that Sir James should mention to His Grace the Duke of Richmond that the placing of guns on top of the Ness would greatly strengthen the place].

[4] *22nd May 1794. To Sir James Wright.*
[In this letter Jordan says there has been a general meeting of the inhabitants to discuss the matter of the fort] ... but it was not well attended so nothing was done. [He demands a supply of cannon and says that the place has been inspected by the Duke of Richmond, who agreed that it was defenceless and promised six cannon, powder and shot. A Volunteer Artillery Company is to be raised to fire the guns].

[5] *31st October, 1794. To Sir James Wright.*
[Jordan reports that a battery has been formed consisting of 65 men commanded by Captain Waye] The uniform is a blue jacket, turned back with red. £200 has been raised to rebuild the fort, which is to be on a segment of a circle about 110 ft in diameter. Height above the level of the ground will be 8 ft. It will be capable of containing four guns - 12 pounders.

[6] *5th June 1795. To Lord Clifford.*

... this morning very early ... three fishing boats belonging to Brixham anchored off Peacke Rock, Bitton, on a bed of mussels belonging to the fishermen of this town and as soon as the tide should leave them, the men on board (9 in number) intended to load their boats with the mussels. In consequence, I immediately ordered two constables to accompany me and with them I went and interrogated the boats' crews relative to their proceedings and intentions. They informed me that one, Martha Harvey of Shaldon, (I presume, my lord, without any orders from you or Mr Knight) had sold them three boat loads of mussels for nine shillings, and ordered them where they were then at in order, at low water, to take them. I ordered them on any account not to touch a mussel as there were not sufficient in the Port to serve the purposes of the fishermen and for the use of the poor. Accordingly they desisted but not without complaining. I hope my conduct will meet with your Lordship's approbation, especially when I inform you that the lower class of people in the town manifested much uneasiness and threatened to go to stone the men. My intervention prevented a serious riot from taking place. Indeed, as the times are so exceedingly hard and every article of sustenance so exceedingly dear, these mussels afford many comfortable meals to the poor of all descriptions and therefore I do not wonder that they should be so jealous of losing so necessary and so cheap a part of their food. Mussels are of such benefit to the fishermen and to the poor of Teignmouth that I sincerely hope your Lordship will not permit any to be sold out of the parish. It has given me great concern to see the quantities of small oysters taken from this river, carried away to breed in other rivers without any method taken to prevent it

[7] *8th July 1795. To Sir James Wright*

.... I am sorry to inform you that Teignmouth House remains untenanted as is the case with all the large houses in Teignmouth It seems strange that the beautiful and varigated views and scenes round, and the fine, open, pure air of Teignmouth should be forsaken for the contracted views and the confined air of Dawlish - but so it is - for Dawlish is at this time quite full of lodgers.

[8] *31st March 1796. To Duke of Portland.*

[Jordan reports that a quartern loaf is selling for 1/-] Most people bake their own bread in the public ovens. For economy bread is made of two parts wheaten flour and one part potatoes.

[9] *27th October. 1796. To Sir Lawrence Palk.*
[A complaint that the trebling of the Militia will force up the price of bread].

[10] *12th July 1797. To Sir James Wright.*
.... I am extremely fearful, so is Mr Towill, that M. Tourneur, who has been a Newfoundland merchant and is known to several people of this town, will endavour to secure more of the island of Newfoundland for France.
[M Tourneur was one of the Commissioners appointed by the French Republic to conclude a peace with Great Britain. The peace plan aborted. It was generally believed in Teignmouth that aggravation between the French and Devonian fishermen on the Grand Banks was one of the minor causes which led to the outbreak of the Napoleonic War.]

[11] *11th November 1797. To Sir Lawrence Palk.*
[Mr Jordan outlines a scheme to alleviate the Poor Law tax. It embodies the maintenance of the poor without parochial relief. He also mentions a school of industry in Orchard Gardens].

[12] *14th March 1798. To Rev. Wm Short.*
[He outlines a scheme for sick relief by means of something approaching the Friendly Society of the twentieth century].

[13] *7th August 1798. To Sir James Wright.*
I have sold the cottage in Parson Street to Bellamy for £35 I have bought a sloop called the *Racehorse* for £400 and am trading pipe clay to Liverpool and coal from Cardiff.
[In the churchwardens' accounts of West Teignmouth in 1821 William Bellamy paid six years conventionary rent and land tax on a house in Parson Street to the sum of £4.18s.0d. He later offered to buy the house for £45. This must be a separate property from the one mentioned by Jordan.]

[14] *8th October 1798. To Mr James.*
I have sent a plan of the new row of cottages to be built in the Marsh to several gentlemen I doubt not the whole ten buildings will be engaged in a short time Before I conclude I beg leave to say a few words relative to the keeping of the water out of the outer Marsh. Your plan has been communicated to several gentlemen but no person seems willing to subscribe unless they benefit thereby. I would therefore

propose if any 20 of 30 gentlemen undertake to keep the water out by building a wall across Rat Island and dig and complete the canal as high up as Long Bridge, I would advise Lord Courtenay to grant them an absolute term of 60 years therein at a very small conventionary rent. No more than one house in the centre should be permitted to be built on the ground which should be converted into pastures intersected with walls and a few clumps of trees planted therein.

[15] *21st December 1798. To Rt. Hon. William Pitt.*
[Mr Jordan suggests a scheme to assist the poor rates and parish relief. It is substantially the same scheme as he recommended to Sir Lawrence Palk on 11 November 1797. He envisages a tax on income] ... from a person whose labour procures him 12 shillings or more weekly, to contribute 1½d.
[Robert Jordan must have been a little behind the times. Income Tax was, in fact, introduced in this year although it was not intended for poor relief. Tax was paid on a sliding scale on incomes of between £60 and £200 per year. The highest rate was 10%].

[16] *21st December 1798. To Sir James Wright.*
[He asks if he may be put forward as a commissionner if the scheme he outlined to William Pitt is taken up. The scheme fell through, but Robert Jordan appointed himself Customs Officer for West Teignmouth at a salary of £100 per annum in 1799. A consolatory position, no doubt].

[17] *6th October 1799. To Mr. Andrew Griffen Tucker.*
Notwithstanding the lateness of the season and such continual wet weather as prevailed for some time past, Teignmouth is still full of company and enquiries are daily making for purchasing building plots Four houses are to be immediately built on the Den by Mr G Templer and his brother Henry, and several others will be begun by spring. People are absolutely building mad.

[18] *25th November 1799. To Sir James Wright.*
A new gallery is in contemplation to be built in the North aisle of West Teignmouth Church for the accommodation of the genteel part of the inhabitants.

It was Robert Jordan, too, who in 1835, in conjunction with Sir Warwick Tonkin, devised a seal for the town of Teignmouth. The crest was taken from the crest which was engraved on the portreeve's staff:

Saltire between four converging fleur de lis.

During the eighteenth century justice was administered by a Court Baron and a Court Leet – the equivalent of a County Court and a Magistrate's Court. The Court Leet, held once or twice yearly, tried all petty cases relative to the inhabitants. A jury was nominated, four constables, a water bailiff deputed and a portreeve was chosen. The portreeve's staff was of wood about four feet long with an iron spike. The arms were engraved on a metal collar at the upper end. The staff, provided with nails spaced at regular intervals to add up to multiples of 36 inches, could also be used for checking measurements. Hubert Parry saw the staff in 1912, but it seems to have vanished since then.

The Portreeve's Staff

The water bailiff had a badge of office – a silver oar eight and a half inches long with an inscription on one side: 'Royalty of St Nicholas on the River Teign', (another proof of the antiquity of Ringmore). On the other side was the letter C for Clifford surmounted by a Prince of Wales' crown.

The lords of the manors were responsible for the setting up of the courts and the machinery of justice. Lord Clifford in West Teignmouth was able to demand from his tenants in fee the sum of £15.4s.7d yearly – the equivalent of one shilling per acre on the manor. If further land was reclaimed from the river or sea he could increase the charge proportionately.

In 1802 the ties between East Teignmouth and the Church were finally and completely broken. The manor was sold to the Courtenay family under the Act for the Redemption of the Land Tax.

8 THE JORDANS AND OTHERS

Robert Jordan was descended from a family of tradesmen (coach builders and the like) who settled in East Teignmouth in the seventeenth century. His great-grandfather was William Jordan who married a lady called Elizabeth in 1690. No details are known about the pair, nor even Elizabeth's surname. Of their children the second son married Loveday whose surname is also unknown. Their son Rufus (born 1715, died 22 December 1786) married Thomazine Hall, stated by Robert to be 'one of the many daughters of Joseph Hall', in 1758. Joseph Hall of Teignmouth House was the great-great-grandson of Joseph Hall, Bishop of Exeter in 1627 (died 1652) who married Elizabeth Winiffe and spent some time at the Lower Bitton House in Teignmouth.

Joseph junior cannot have been very keen for his daughter, Thomazine, to marry Rufus Jordan – the descendent of tradesmen – although Robert, himself, was an up-and-coming young man, dabbling in trade, money-lending, and various other profitable pastimes. Thomazine was 32 at the time of her marriage, and seems to have been the eldest of several daughters. It was imperative to marry her off. Rufus was keen to marry into such a family; Thomazine was keen to marry him. The marriage took place and the couple spent almost 30 happy years together. Of their five children Robert was the second son. He was an extremely able and clever man but, reading between the lines, his motive force appears to have been the making of money and the translation of his family to the upper ranks of Teignmouth society.

In 1788 Robert, an up-and-coming banker, money-lender and scribe, married Nancy Stooke in West Teignmouth Church. His father, Rufus, had bought property in West Teignmouth and on a map *c.* 1760 is shown as

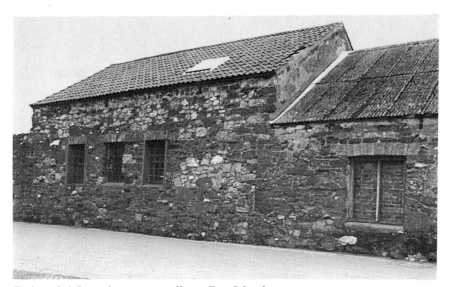

Ruins of eighteenth century walls on Rat Island

owning a 'cellar' on Rat Island which had been formerly the property of Richard Reynell of Ogwell and which was immediately behind some further cellars and a house belonging to that gentleman. The cellars were in reality fish stores: no doubt used for storing Newfoundland cod and other merchandise brought in by sea. Robert, the only surviving son of Rufus received a good education, could read, write and figure and was considered 'very sharp'.

The Stookes, originally a farming family from the Stokeinteignhead area, moved to Teignmouth after William Stooke married Mary Seaward. They went into business as ironmongers, plumbers and tinmen. The daughters and grand-daughters married into the Penson and Tapley families. William Tapley Stooke, a nephew of the seafaring Tapleys, born in 1825, took over the ironmongery business in Teign Street.

Robert and Nancy had seven children including twins. They were delicate and all except William Rufus, the second son, a twin, died young. It is interesting to note in view of their father's social aspirations that the children's names included Hall – from Robert's grandmother, and Risdon – an unproven ancestral connection. Nancy and Robert lived first at Gibraltar Cottage, Triangle Place and later at Lugehay House in West Teignmouth.

William Rufus inherited money and property from his parents. He became a notary with banking and seafaring interests. His first son, William Risdon Jordan, born in 1817, died at the age of three years. His second son, William Risdon Hall Jordan, was born in 1821. He married twice – first Mary Sandford, then Louise Mary Valache, the daughter of a merchant. His son by

his second marriage was William Frederick Cartwright Jordan, a respected solicitor who died in Teignmouth in 1934, but of whom Miss Kate Anson Cartwright said very firmly 'He was a friend of my family, but never a relative'. This Jordan lived in Winscot, Higher Brimley which he named for the family home of the Risdons near Great Torrington.

It was Robert Jordan, born in 1760, whose letters were quoted in the foregoing chapter, who conceived or implemented the plan to drain the marsh and to release a huge area of building land at a time when people were 'building mad'. Before the year 1800 the plan had been put into operation but not yet completed. Jordan, together with a consortium of other businessmen had raised the money to build a wall across the whole estuary of the Tame, to channel the stream into a canal and so to reclaim all the marshy ground in the centre of the town, as far as the Long Bridge which stretched across the Tame behind the present W H Smith's shop, reaching from Clampit Lane to the other side of the present Station Road. The Triangle remained for some while with trees and an open space as Jordan suggested, but the land hunger was so great that it was later utilised for other purposes. The canal through which the Tame flowed was covered in the last century and now forms part of the town's main sewer. Names associated with the draining of the marsh were Langley, Stooke, Sir James Wright, Pitt (a local family), Templer, Holland, James and others.

In 1808 Robert Jordan went into partnership with Mssrs Langmead and Holland to set up the Teignmouth Bank. Robert became a churchwarden at St James' Church and clerk to the committee. He was not only the motive power behind the building of the new gallery mentioned in his letters, but was also involved in the rebuilding of the church in 1819. His wife, Nancy, died in 1826. She had been left property in her own right on the death of her father, William, in 1807. His will left Lugehay House to his daughter, Nancy Jordan. Nancy and Robert were already resident in the property. On the death of Nancy the house and lands called Norrishes Lands (unidentified) were to pass to her son William Rufus Jordan and his heirs and assigns for ever. Additional parcels of land were left to Nancy's other children.

The notebooks of Robert Jordan contain a surprising amount of detail about the economy of Great Britain at the end of the eighteenth century. For instance he notes that in June 1795 the weekly consumption of corn in the whole country was 180,000 quarters; the price of grain at Rumford market on 22 April 1795 was: wheat 8/6d to 8/9d per bushel, barley 4/6d to 5/-, rye 5/- to 5/3d, and oats 3/9d. There are personal comments such as a note on the anniversary of the death of his 'dear mother'. From his letters – previously quoted – we learn much about life in Teignmouth. The town was the resort of the nobility (letter 1), there was a boat building yard in Ringmore (2) – in fact there were three owned separately by Mssrs Tucker, Sutton and Stephens –

that the town felt vulnerable (3), that preparations were being made to repel attack (4,5), that the standard of living in the town was low and there were many poor (8,9), that Dawlish was a growing town (7), that the marsh was in process of being drained (14,17), that the enlargement of West Teignmouth Church was being considered (18). The 'new walk' (2) was the path constructed around the perimeter of the Den above the swamp.

As a footnote to letter 12, the Teignmouth Beneficent Society had been formed in 1793 and was working well with a limited membership. It fell into disuse in 1795, but was recovened in 1808 – under the chairmanship of Robert Jordan.

An entry in a book recording leases and sales of land mentions that in 1795 a quarter acre of land on the right hand side of the road leading from St James' to Bitton was held by John Taylor. A dwelling house, stable, garden and other premises in Daimond's Lane was in 1806 the property of William Penson. Penson, described as a ship owner, was later hanged for stealing a sheep. The property referred to the Daimond House. Penson was a relative of the Stookes by marriage and so of the Jordans. The last Stooke, Ellen, died there in 1908.

The curate of West Teignmouth moved from the Priest's House to a more commodious house in Parson Street in 1816 – hence the name. The parsonage was on the left going down the street, just above the present railway bridge. From that time each church was served by a separate curate but it was not until 1867 that a vicar, the Rev. Birch was appointed for West Teignmouth.

The Daimond of Daymond who built up Daimond's Lane at the end of the century cannot be traced, but since the name changed from Church Street about that time, it is reasonable to suppose that he was active about then.

The Holland, partner with Langmead and Jordan in the banking business, was an extremely wealthy man. He lived at Barnpark, later called Woodlands and now the Woodlands Hotel. Local legend has it that he buried his 'treasure' in the grounds when the threat of invasion by Napoleon's forces was acute, and that it lies there still.

The estate stretched from beyond Brimley Brook (River Tame) in the west to Barnpark Terrace in the east. After the banker's death the land was divided – that in the west going to Mr Bartlett of Brimley House. Mr Holland was responsible for building on of the first streets on the land reclaimed from the marsh – Holland's Row or Road.

The Langmeads in the banking business came from the northern fringes of Dartmoor where they had farmed since Norman times. They took their name from the farm.

The Langleys, whose name has frequently cropped up in this chronicle, appeared in Teignmouth about 1740. On the map of 1759 Mr Langley held a lease on a house, cellars and courtledge on Rat Island. At that time Rat Island was separated from Teignmouth by the main channel of the Tame. It fell

within the parish of East Teignmouth. The Ferry Boat Inn (Jolly Sailor) had lost much of its trade with the movement downriver of the ferry crossing. The property held by Langley may well have been the inn – or buildings which remain in part just above the inn. (At the end of the eighteenth century the Jolly Sailor was – under its present name – used as a recruiting point for sailors for the Napoleonic War. Many a heavy drinking seaman found, when he had drained his pint, that he had taken the king's shilling).

Shute Hill House in the twentieth century

About 1795 Mr William Langley built Shute Hill House on the site of an old farmhouse. Its land stretched down to the Tame on one side and to the marsh on another. The building was later enlarged and a (then) fashionable parapet added to the roof. A small upper room was incorporated as a Catholic Chapel. The Langleys continued there until the early twentieth century. Miss Beatrice Langley, last of the line, was a well known violinist. The family claimed descent from Edmund of Langley, fifth son of Edward III.

By the year 1800 the Newfoundland trade, made dangerous and expensive by the war which involved both the French and the Americans, was in the doldrums. In 1770 there were 43 ships engaged in the business; in 1790 there were only 26 and 20 of these sailed directly from Teignmouth. Of these 20 only six were fishing boats; the remainder were sack ships – that is they were trading goods to the inhabitants of Newfoundland and bringing back salted

cod. The boats were unloaded in West Teignmouth, by Rat Island. Ship-building yards were a little further downriver.

In Shaldon there were also three jetties used by the fish trade; Coombe Cellars was a salting place. It was also a centre for smuggling and continued to be so for many years. W H Thornton was a deckhand on a boat called the *Traveller*, owned by Mr Screw of Teignmouth, captained by Mr Rothan. He published his autobiography in 1840 in which he gives this account:

> It was only on dark nights that Rothan would stand inshore and wait for the answering signal on the cliff (Labrador). That signal told of safety. Then he landed his cargo which generally consisted of about 120 kegs of brandy each four gallons. He would be met on the beach by a number of badly paid labourers from Stokeinteignhead. Each man took two kegs which together weighed about 70 pounds. In absolute silence the long procession made its way through fields down to Coombe Cellars. This was a central place for the smuggling trade and from it travellers were quickly ferried across the Teign. On the further side they resumed their loads and toiled painfully on, generally to Humber Moor where the kegs were concealed in a morass. Their remuneration was 5/- per man.

In a thatched cottage by Ringmore Church is a small circular window, reputedly a wreckers' window, used to show a light which would lure ships onto Ness Rocks. There is considerable doubt about the authenticity of this story. However, wrecking was commonplace in the eighteenth century and many unfortunate sailors, alive when the ship struck, lost their lives at the hands of the marauders. A statute of William III forbade anyone to land on a wrecked ship 'while a man or a cat was alive'. This led to the death of some men and many cats.

In the early nineteenth century French prisoners of war were housed in a gaol at the bottom of Willow Street – possibly part of the fish-storing house. They managed to escape and set off for France (presumably) in a small schooner, the *Griffeth*, which they stole from the estuary. There is no mention of their recapture.

Teignmouth was, at this time, a lawless place. Robert Jordan speaks in his letters of robberies and break-ins, and, of course, there was smuggling and wrecking and all manner of mayhem as there always is in wartime. To cope with the crime-wave a gibbet was set up on the top of a hill between Shaldon and Stokeinteignhead, whence it was visible for many miles. There was also a gibbet in Bishopsteignton. Some lawbreakers were caught and hanged; others were not. Many a fortune was dubiously earned in Teignmouth.

In 1800 East Teignmouth consisted of 88 houses. West Teignmouth had

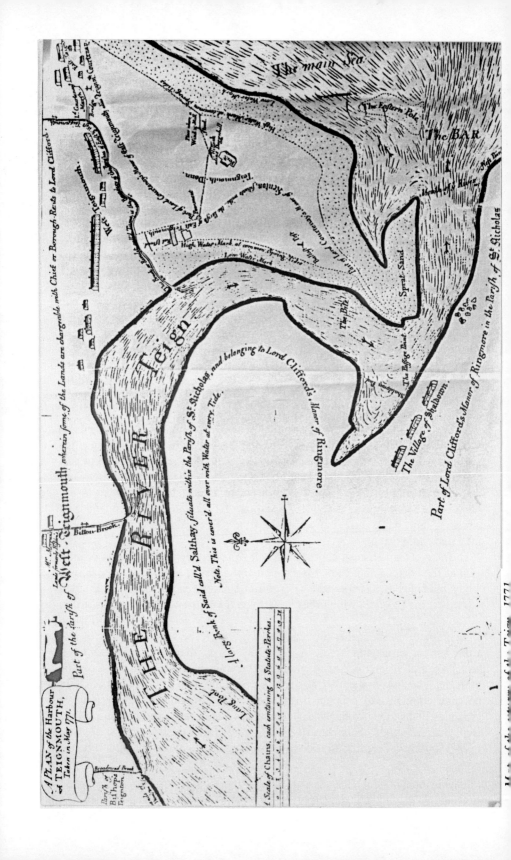

A PLAN of the Harbour of TEIGNMOUTH, Taken in May 1771.

Part of the Parish of West-Teignmouth wherein some of the Lands are chargeable with Chief or Borough-Rents to Lord Clifford.

Parish of Bishops Teignm.

Broadward Point

Bitton Brook

THE RIVER Teign

Long Pool

A large Bank of Sand call'd Salthay situate within the Parish of St. Nicholas, and belonging to Lord Clifford's Manor of Ringmore.

Note, This is cover'd all over with Water at every Tide.

A Scale of Chains, each containing 66 Statute-Perches.

The main Sea

The Eastern Pole

The BAR

The South Hale's

Low Water Mark

High Water Mark

Teignmouth-Dean

Part of Lord Clifford's Manor of Ringmore

Start's Lip

Bar of Lord Clifford's Manor of Ringmore

High Water Mark at common Spring Tides

Low Water Mark

Sprat-Sand

The Bite

The Pilsey Bank

The Village of Shelborn

Part of Lord Clifford's Manor of Ringmore in the Parish of St. Nicholas

Map of the entrance of the Teign, 1771

1,016. The joint population was 2,012 persons –from which it can be inferred that houses were leased to visitors for only part of the year.

By 1823 the population had risen to 3,980 persons.

Many French aristocrats came to England – to the West Country – after the outbreak of the revolution in 1789. They had money, and built themselves new homes in their new country. Cambrian Cottage in Dawlish Road is such a place. It has eighteenth century chimneys, an Adam fireplace and is now a listed building. In the following century it became the home of Admiral Wight.

Hermosa House, built few years later, was the home of the Sweetland family, whose origins are obscure, but they too were wealthy. Their land stretched from Coombe Vale Road to Daimond's Lane; their memorials remain in St James' church.

Venn Farm was the home of the Narramores. On their land were several lime kilns, used for burning the fresh lime brought in by sea from Berry Head so that it could be used as a fertiser on the acid Devon soils.

In 1774 Bitton Mill was still in working order and run by Mr Thomas Wills. The leat can be seen running through the gardens of a house called Silver How in Mill Lane. It was led across the hillside from Bitton Brook. When the mill was demolished the mill stones were incorporated into the wall at the beginning of Third Avenue where they can still be seen.

9 THE RICH AND THE FAMOUS

During the Napoleonic Wars many naval officers brought their families to live at Teignmouth. Their ships frequently sheltered in Torbay, but Torquay was little more than a village with none of the attributes of smart living. With their prize money they built houses such as Trafalgar Cottage, Cliffden, Eastcliff and so on. All this added greatly to the prosperity of the town. Teignmouth became a leading south coast resort. The Prince of Wales (later George IV) had made Brighton fashionable and the benefits of sea air and sea bathing were loudly extolled. Everyone who was anyone wanted to live by the sea. Teignmouth and Dawlish were cheaper and prettier than Brighton – and just as healthy. A comment made by Charles Lamb in 1815 about seaside town reads: 'I have been dull at Worthing, duller at Brighton and dullest at Eastbourne but I quite enjoyed a week at Margate.' Of course he had never visited Teignmouth.

Another writer did stay in Teignmouth, however. John Keats spent the spring of 1818 in a newly built house on the Strand – on land reclaimed from the marsh. Houses in that area have been renumbered so many times it is impossible to be sure exactly where the poet lodged but we know from his letters that the house was a corner house, that he had a view up the river and that there was a glove shop opposite. He became friendly with the owner and the assistants. His comments on Teignmouth are coloured by the facts that the weather was atrocious – wet, cold and windy, that he was in poor health and that his brother, Tom, who was with him, was dying of consumption. The preface to *Endymion* is subscribed 'Teignmouth, April 10th, 1818'.

Elias Parish Alvars, the composer and harpist, was born in East Teignmouth in 1808 at 27 Regent Street. Again, renumbering makes identification of the house impossible. His father was a music seller and became organist at St James'. The church wardens' accounts 13 October, 1811 relate:

At a meeting holden of the parishioners of West Teignmouth in the Vestry ... it was resolved that the organ belonging to Elias Joseph Parish should be purchased and placed in the church and the said Jos. Parish be appointed organist at a salary of 10 gns per annum.

It is not known how long Parish Alvars lived in Teignmouth although in 1823 his father is listed as a music seller at 10 Wellington Row. The composer wrote an opera, *The Legend of Teignmouth*, and another, *Scenes of my Childhood*, which imply that he spent and enjoyed his youthful years in the town, but as quite a young man he travelled abroad and gave concerts in

Elias Parish Alvars

France, Germany, Italy, Austria, Mexico, California and the the West Indies. He took the surname Alvars from a patronne. He married his pupil, Melanie Lewy, in the late 1830s; they had a small family. In 1842 Berlioz wrote of him:

> In Dresden I met the prodigious English harpist Elias Parish Alvars, a name not yet as renowned as it ought to be This man is the Lizt of the harp. You cannot conceive all the delicate and powerful effects, the novel touches and the unprecedented sonorities, that he manages to produce from an instrument in many respects so limited.

Parish Alvas died – not quite 40 years old – on 25 January 1849 at his home in Vienna.

The marine artist, Thomas Luny, settled in West Teignmouth soon after he became paralysed and had to live on a small pension. His first home was at Oak Tree House, which was situated between the present Triangle and Courtenay Crescent. Later he had built a house in Market Street (Teign Street) and lived there until his death. The house, marked with a plaque, still stands and is called the Holiday Inn. He and his half brother James Wallace, together with other members of his family are buried in West Teignmouth churchyard.

George Muller, preacher and philanthropist, was Pastor of the Congregation at Ebenezer Chapel, Teignmouth from 1830-1832 after which he went to Bristol and devoted himself to the care of orphans. He married Mary Graves, sister of Anthony Norris Graves who founded the Plymouth Brethren in Teignmouth in 1826.

In a letter written in 1792 (previously quoted) Robert Jordan mentioned that the rent of Bitton House (Lower Bitton) had been distributed to the poor of Teignmouth according to Mrs Risdon's will. The house had lately been leased by Mr Praed. In fact Mr Praed leased it in 1791 for 99 years for £100 and rent of 10/- per annum. The £100 was used by the Guardians of the Poor to erect 5 small tenements adjoining the workhouse, for the use of the poor.

The Praed family are interesting. They were landowners in Trevethow near Lelant, Cornwall before 1600. John Praed, a younger son, was of an adventurous and spendthrift turn of mind. From 1708-1712 he was Member of Parliament for St Ives and during this period he contracted a number of debts. On the death of his elder brother in 1712 he inherited the estate, but was disappointed to find that most of the farms were leased at very low rents and that the whole estate was of little value to him. Accordingly he entrusted the management of his affairs to his nephew, John Penrose, and returned to London. Penrose seems to have leagued himself with some of Praed's debtors and John Praed was arrested for debt. A friend, Sir Humphrey Mackworth, head of an old and wealthy Derbyshire family, offered to pay off Praed's debts

on condition that the man adopted William Mackworth, Sir Humphrey's son, as his heir. William Mackworth was to assume there name of Praed and a marriage to be arranged, if possible between himself and the daughter of John Penrose, Bridget, who was an heiress in her own right. Sir Humphrey also guaranteed an annuity to John Praed for life. The conditions were accepted and the indentures were signed on 28 July, 1714.

The Mackworths took their family name from their seat, the village of Mackworth and claimed descent from Thomas Mackworth who married Ann Basings, heiress of a Rutland estate. During the Civil War Colonel Humphrey Mackworth, grandfather of Sir Humphrey, had been governor of Shrewsbury and was rewarded for his services to Parliament by the presentation of a chain of gold and a medal, to the value of £100. He received much honour in his lifetime, but after his death and the restoration of Charles II, his body was exhumed and flung into a ditch in St Margaret's graveyard. By 1714 the family had re-established themselves; but Sir Humphrey (whose grandson received a baronetcy in 1776) was not quite as philanthropic as he appears at first sight. For the price of John Praed's debts he secured for his younger son a large estate and the chance of a rich marriage, while he himself was under a cloud having been found guilty of peculation by the House of Commons in 1710. The Praed name was untarnished.

Everything did not go as planned. Bridget Penrose did not welcome the suit of William Mackworth and started a suit to contest the transfer of the Praed property. It is said that after a ceremonial call on the lady William had some difficulty in escaping with his life. He then lost interest in pressing the marriage and finally married a Miss Ann Slaney, having reached an agreement with the Penrose family over the property. On the death of Ann, a few years later, he married Martha Praed.

John Praed, the spendthrift, died in 1717, having enjoyed his annuity for only three years, and the estate duly passed to William Mackworth (Praed). William had five children by his first wife Ann. The eldest was Humphrey who founded the banking house of Praed and Company. Praed Street, London is named after him. The second son, William, made a fortune in the wool trade and bought a sizeable amount of property in the Alphington area of Exeter. He became Member of Parliament for Exeter, founded the Exeter Bank in 1769 and instigated the building of th Royal Clarence Hotel in Cathedral Close which was described as the first real hotel in England. It was this same William called Mackworth Praed who leased Bitton House (Lower Bitton) in 1792 as a pleasant summer residence for himself and his family. Shortly after the drawing up of the lease he died and Bitton House passed to his son, another William, who had been born in 1756 and was his eldest child. William, junior, was by profession an attorney and had become Sergeant-at-Law.

In 1795 he married Elizabeth Winthrop, daughter of Sir Benjamin Winthrop, Governor of the Bank of England. One of Elizabeth's ancestors had been Governor of Massachusetts in 1638 and the family is still exant there. A novel by Anya Seton, *The Winthrop Woman*, deals with this branch of the family. Elizabeth and William had five children, several of whom were consumptive, so the family spent most of the year at Teignmouth in order to enjoy the pure and curative sea airs. On his retirement in 1820 Mr Praed decided to live permanently at Bitton House. In the previous year he had bought a house and garden plot in Bitton Street near his home and these he intended to use for the purposes of enlargement. He refurbished Lower Bitton House and lived there in style, being the first resident of Teignmouth to own a coach. The building of the river road from Teignmouth to Newton Abbot was instigated by him.

Meanwhile, between 1795 and 1800, another house had been built on the lands of Bitton. This was Westcliff House, now known as Bitton House. The new building was sold in 1812 to Edward Pellew, Lord Exmouth, a distant relative of the family.

Winthrop Mackworth Praed, the poet, was the third child of William Praed. He was born in London in 1802 and brought up after the death of his mother in 1810 by his elder sister, Elizabeth, to whom he was devoted. His younger sister Susan, however, was his friend and confidante and the recipient of many of his letters. It is remarkable that his father, his mother and sister were all versifiers.

Winthrop passed most of his childhood at Teignmouth, suffering from the family tendency to ill health. In later life when he wrote under the name of Peregrine Courtenay many of his poems referred to the little town which he regarded as home. Describing Lower Bitton House in a sentimental fashion he writes:

> There beamed upon the riverside
> A shady dwelling place.
> The river with its constant fall
> Came close up to the garden wall
> As if it longed but thought it sin
> To look into the charms within.
> And just before the gate there stood
> Two trees which were themselves a wood;
> Two lovely trees whose clasping forms
> Were blended still in calms and storms
> Like sisters who have lived together
> Through every change of fortune's weather.

Another poem describes life in Teignmouth – a round of picnics, balls and other entertainments in the newly built Assembly Rooms.

Winthrop Mackworth Praed was called to the Bar and also entered Parliament as MP for Great Yarmouth. In 1835 he married Helen Bogle. His health had always been poor and he died in 1839. He is buried in Kensal Green Cemetery, London.

Westcliff House (now Bitton House) showing cannon captured at the Seige of Algiers

Sir Edward Pellew purchased Westcliff House in order to be near the sea. About 1820 he bought an estate at Canonteign. One of a family of six he had entered the Navy at the age of 13 years and worked his way up. He captured the first frigate in the war with the French in 1793 and in 1796 saved the passengers and crew of a transport ship at Plymouth. He prevented a mutiny in 1799, and was made Rear Admiral in 1804. In 1814 he became Admiral of the Blue and in 1816 he bombarded Algiers and freed the Christian slaves, for which service he received a Viscountcy. Unable to take the title Teignmouth, since there was already a Baron Teignmouth, he became Lord Exmouth. He died at Westcliff House in 1833. Readers of the C S Forester novels about Horatio Hornblower will be interested to learn that Lord Exmouth was the prototype of Hornblower. Almost all the latter's exploits are based on incidents in the life of the former.

The two cannon which stand outside the front door of Bitton House were brought back from the siege of Algiers by Lord Exmouth. A story recorded by Beatrice Cresswell and repeated in an earlier edition of this History is untrue. It was stated that part of the rock on which the *Royal George* was wrecked was brought by Lord Exmouth to Bitton House and later moved to Rowdens, in Dawlish Road. The *Royal George* did not strike a rock: it overturned in The Solent.

The days when Edward Pellew lived at Westcliff House were the brightest and best in the annals of Teignmouth's history. His presence attracted retired naval officers and their families and ensured that the town was worthy of them. He took a prominent part in the affairs of West Teignmouth, was a keen churchman and a prime mover in the plan to rebuild St James's in 1819. After the church was completed, Mr Praed fell out with the trustees and refused to pay his church rates, being disappointed in the seating he was allocated. He blamed Robert Jordan and hinted at irregularities. After a lengthy and acrimonious correspondence between the two men, Lord Exmouth intervened to pour oil on troubled waters, and the matter was settled.

After Lord Exmouth's death in 1833, Canonteign became the home of the Pellews until 1981 when the estate was sold. The Praeds moved to Westcliff House in 1833 and remained there until 1863. The plaque recording Bitton House (Westcliff House) as the home of Winthrop Mackworth Praed is only true in that his parents lived there for the last six years of his life, but the town is naturally proud of him. Something of a character in his own day it is recorded that he once appeared in the gallery of St James' with 'his hair brushed into a tuft on either side of his head, and a wide velvet collar turned down over his overcoat.'

Teignmouth House, the home of the Halls, was leased out from the end of the eighteenth century as follows: Sir James Wright (1795); Chicel Michell, an East India man (1806), and Mr Temple (1830). In 1863 it was bought as part of the Bitton Estate by Mr John Parson, Chairman of the Metropolitan Railway, who also bought Westcliff House and Lower Bitton House from Elizabeth Praed. He demolished Lower Bitton House and sold Archery Field across the road, formerly the venue for archery tournaments. Westbrook Avenue was later built on it. Only the stables of Lower Bitton House remain, now converted into a sports club-room. Mr Parson renamed Westcliff House, Bitton House.

The last of the Praeds, Mrs Rosa Caroline Mackworth Praed, widow of Arthur Campbell Mackworth Praed, great-great-grandson of William, Sergeant-at-law, died in Torquay in 1935.

The orangerie at Bitton House has been the source of some interest in the last few years since it was once thought to have been the work of the famous architect, John Nash. During restoration of the building the name S Hayman

and the date February 3, 1842, were found inscribed on one of the timbers. The words had been protected by a moulding and are unlikely to have been added after the orangery was constructed. Samuel Hayman, whose descendant William Hayman was recently living in Pennyacre Road, was a joiner and builder – born 1809, died 1877. The stucco building is certainly in the style of Nash, but it was fashionable to build in that manner. After his bankruptcy at the end of the eighteenth century, Nash did little work in the West Country, his activities being largely confined to London. However, the Orangery is a fine building and well worth all efforts to preserve it.

Westcliff Cottage, perhaps originally used as a lodge for the estate – either of Teignmouth House or Bitton House, stood on the site of the present telephone exchange and was the twentieth century home of Mrs Gray. The house was damaged by enemy action during World War 2, as was Bitton House, and was later demolished.

In 1899 Mr Parson sold Bitton House to Mr F Slocombe who built Bitton Avenue. Bitton Crescent and Alexandra Terrace in the grounds near where Teignmouth House had stood. In 1987 an underground tunnel was discovered running parallel to Bitton Street from the site of Teignmouth House towards Bitton House. It is conjectured that it was a water conduit. There are known to be springs (wells) near St James' Church and near the top of Clay Lane. Water from there may have been carried to Teignmouth House and Bitton House. The style of the tunnel is that of an old water course.

In 1904 the last of the Bitton Estate was bought by Teignmouth Urban District Council. During World War I the house was used as a hospital after which it was empty until 1928 when it was converted into Council Offices. Taken over by Teignbridge District Council under the new Local Government legislation, it is now returned to the town and will be used as a Community Centre.

A model of the whole Bitton Estate as it was in 1863 was made at the request of Mr John Parson. It was presented to Teignmouth Urban District Council by Mrs Barklie, formerly Miss Parson, in 1928 and can now be seen in the local Museum.

Charles Babbage was a mathematician. Totnes or Teignmouth was the place of his birth. His father, Benjamin Babbage, was a banker working with the house of Praed, and Charles went to school in Alphington. It would seem therefore more likely that he was born in Teignmouth – the home of the Praeds who had interests in Alphington, and handy for Exeter. The date of his birth was 1792. Quite early in life he showed himself to be a mathematical genius. Algebra, which was not taught at his school, he taught himself, and in his teens he went to Cambridge where he had a distinguished record. He was friendly with Herschel, the astronomer, who lived for a while at Dawlish, and helped him to found the Royal Astronomical Society.

Regent Place, c. 1820, showing Croydon's Library (now W H Smith's shop)

In 1812 Babbage had an idea for a mathematical calculator. In 1820/22 he built a small engine to do this work and gained a gold medal from the Astronomical Society. Soon afterwards government funding for his work was withdrawn but he continued to experiment using his own fortune. In 1826 he produced a machine with two sets of variable cards – a simple computer which received much acclaim. In 1830 (or soon after) he put forward a plan for an Analytical Engine. The 25 foot machine was to perform difficult calculations using a complicated series of gears and axles. It could be programmed with punched cards. The machine was still in the process of construction at the time of his death in 1871, largely because he could not obtain the parts he needed. Rightly, however, he has been entitled the 'Father of the Computer.'

The Babbages lived until approximately 1819 at Rowdens, Dawlish Road, though the initials C B on a stained glass window there relate not to Babbage but to the Barklie family, the later occupants. It will be noted that the Babbages had connections with the Praed family; Mrs Barklie was born Praed.

A human touch – Charles Babbage was peculiarly sensitive to noise and waged an implacable war on organ grinders.

10 SOCIETY DAYS

It was the draining of the marsh by Robert Jordan and his associates which brought into being the Teignmouth we know today. Between 1795 and 1805 the twin towns of East and West Teignmouth were united. No longer was it necessary to ascertain the state of the tide when crossing the marsh by way of the Long Bridge; no longer was one town cut off from the other by floods which extended up the Brimley Valley. The Tame still flowed – confined in a channel, the Canal – through the centre of the town, but it created few difficulties. The reclaimed land was providing prime building sites and Teignmouth was becoming fashionable.

The diary of a summer visitor in 1828 reports:

> This is an excellent town – good shops, good libraries and very handsome public rooms. Fish is to be had here in high perfection. Nothing can exceed the variety and beauty of the minerals found in the mines of his lovely county – a gentleman has hired a place within five miles of here for a term of five years a short time ago, and has found on it a mine of iron, which the landlord cannot prevent him from working, and he is making thousands.
>
> Today, caught by a heavy shower I took shelter in a shell-and-mineral shop and purchased some petrifactions – a stalactite from Kent's Cavern, a tortoiseshell from Berry Head and a 'Venus'.

The influx of visitors markedly underlined the shortcomings of the seating in the churches. Both buildings were in need of repair. Both were village churches, not considered fit to receive fashionable and famous worshippers such as Sir John Strachan and Lord Exmouth.

In 1811 a meeting of the wardens and parishioners of West Teignmouth was called to decide whether the parish was best served by enlarging the existing church or by building a new one. A committee consisting of Henry Line Templer, Thos. Arscott, Robert Jordan, William Cartwright, John Goss and John Bartlett was appointed to look into the matter. It was decided to rebuild at a cost of £5,400. William Bragg of Westbrook House was the contractor and Andrew Patey, of Exeter, was the architect. Work began in 1819 and was completed by 1821. Fragments of the old church were incorporated in the new. The seating capacity was 1,500 persons.

Patey, the architect, had a good reputation, and was much sought after for local buildings since he was a Devon man. He had the old church of St James pulled down except for the tower (which still stands) and created a battlemented octagonal building surmounted by a crenellated dome. Original it may be, but it has little grace or beauty, and the grey granite used consorts uncomfortably with the glowing red sandstone of the old tower. During the building Patey became very short of money and appears to have skimped some of the work. The churchwardens afterwards complained that:

> The caps of the columns under the feet of the groins in front of the intended organ gallery are made of plaster instead of wood and do not correspond with the caps of the iron columns as was intended The plaster trusses under the springing of the groins to the ceiling are very plain The skirting against the walls at the back of the gallery is very mean and anything but what it should be The Purbeck paving in the lobbies of the 'staircases' is very bad The stonework of the windows that was left to Mr Joslin to complete is very badly executed ... which will be very difficult to remedy and in additon to their instability gives them a patched-up appearance instead of new The iron bars are too small

The catalogue continues at some length and mentions that Mr Shimell had been called in to replace some of the woodwork.

Eventually the church was finished – and a very fine church it seemed after the old building which had had its roof propped up by a tree. The old bells, four in number and mentioned by Robert Jordan as 'not very tuneful', were melted down and recast as tenor and treble bells – but this was not done until 1879. In 1821 six bells were hung – they came from a church in northern England. All eight bells were retuned and rehung in 1963. The old pulpit was used in the new church but was replaced in 1900, the original pulpit being made into an archive chest. Other parts of the old church which were incorporated in the new included the altar stone which can still be seen by the Clergy Vestry door, the brass candlesticks – very ancient and lost after the

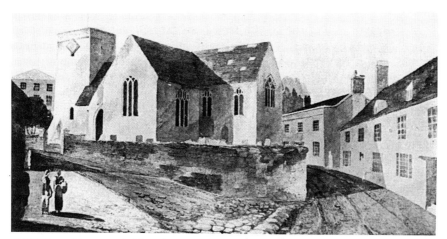

Old West Teignmouth Church

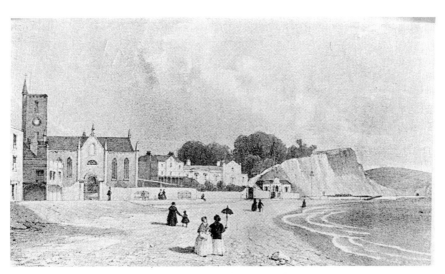

Old East Teignmouth Church

invasion of 1690 – rediscovered by a member of the Jordan family. There is a floor tomb near the vestry door believed to have been formerly one of a pair of altar tombs. This stone was found in 1889 under the woodwork of the floor leading to the north window; its inscription read 'Hic iacit Thomas Smith, obit April 1504.'

In the south wall of the church seen from the outside, is a broken stone which reads: 'Hic iacit' It appears to date from the early seventeenth century and it is tempting to wonder if this is the second altar tomb stone. Some of the more interesting features of the old church had to be lost in the rebuilding. The roof had sagged in the seventeenth century and the parish had appealed to Mr Martyn of Lindridge for a pillar. He had provided a tree trunk – sarcastically known as 'Golden Martyn's pillar'. The King's Arms and Ten Commandments had been set up in the church in 1666 but later moved on account of their rotten state. The Commandments reprinted were placed at the head of the Communion Table.

Immediately after the rebuilding the pew sittings were taken up by the local gentry. Mr Brine of Ness House bought three sittings, Mr Robert Jordan bought one sitting, Mr John Richards (of Winterbourne) bought two sittings, Mr Thomas Luny renewed one sitting and Lord Exmouth paid £145.5s.0d for 29 sittings.

A proud possession of the church today is a silver platen presented by Mary Risdon in the eighteenth century to replace part of the silver stolen in the French raid.

About the time the church was rebuilt some cottages belonging to William Cartwright, which stood on the north side of St James', were burned down. The land was purchased and added to the churchyard.

The tombs of the Praeds, Cartwrights and Luny family can be seen in the churchyard together with tombstones from the graves of such families as the Stookes and the Jordans. There is a large unmarked tomb beside the church which must have belonged to an influential family. It might have been the Halls, or even the Shores.

St Michael's, East Teignmouth, was rebuilt in 1823 in cruciform shape. The architect was again Andrew Patey. The cost was raised by public subscription. The original church had been smaller than that of West Teignmouth. An early nineteenth century incumbent describes it as 'on the beach, on a little rise, with the billows roaring under the walls of its enclosure.' Robert Jordan writing in 1791 says:

> The first structure was small, built according to the account of the ancient inhabitants for the conveniency of fishermen going to prayer before they went about their fishery, and as an emblem thereof several golden herrings were hung up in the church, since which a large

addition has been made to the north, much larger than the first building. In this church is nothing remarkable except the screen which parts the chancel from the body of the church, which is about seven feet high, and in the upper of which there is a cornice, in the hollow of which there is a rude hieroglyphical carving of several grotesque figures. The construction of the roof of the original church is worth the attention of the curious.

Jordan goes on to say that formerly the church had considerable land which kept it in repair, but in latter years this source of income had vanished. In 1744 a great storm had breached the churchyard walls and washed away several graves.

Riverside – 'Mr Kendall's Cottage on the Den, 1816' – now demolished

The new church, by Patey, is unremarkable, but more pleasing to the eye than St James'. Several styles of architecture are mixed, but time has so weathered them that they have blended into a whole; local stone being used. The carved 'Saxon' door was the work of John Kendall of Exeter. John Kendall is also remembered as being the first to build a house on the Den. Riverside, originally Denn Cottage, at the far southern end of the Den, was allowed to go into disrepair and was finally demolished in 1987. It was one of the few old buildings which remained in the town and should have been listed.

During the demolition of the old Church of St Michael, three cannon balls

were found embedded in the seaward walls. These were relics of the French invasion of 1690. The Norman font was replaced by one of Devon marble in 1885. The old font went to St Peter's, Shaldon, in 1902 and is now in Branscombe Church.

St Michael's was restored 1887/1889 and the tower and western walls were rebuilt at a cost of £2,500. A chancel was added in 1875 and a new rood screen was erected in 1923. Again many of the old Teignmouth families have tombs in the churchyard. Burials within both churches became less frequent after the rebuilding. The churchwardens' accounts of St James' mention that in the early nineteenth century it cost 6s 8d to be 'burried inside'.

Further building going on in the town in the early nineteenth century. The old Assembly Rooms, built in the late eighteenth century on the site of the present Esplanade House, East Teignmouth, were felt to be inadequate for the new company in the town, and new Rooms, now known as the Riviera, were erected from designs by Patey.

The new Assembly Rooms where '100 couples could dance at ease' and with many other attractions, were used for balls and other social functions throughout the season. They are mentioned several times in the letters and verse of Winthrop Mackworth Praed. In 1871 the building was handed over to the East Devon Club. In the twentieth century it was converted to a cinema and is now used as a cinema, bingo hall and for similar purposes.

Croydon's Library, now W H Smith's shop, was built in 1815 on reclaimed land. The name 'The Royal Library' can still be seen on the frontage. It supplied the London papers – the Globe, Star and Courier and on Sundays the Examiner. Most of the provincial weeklies were also available. It was not so much a library, in the modern sense, as a club.

In 1802 a theatre was built in Station Road. A plaque commemorating the fact that Edmund Kean played there can still be seen on the building, now an optician's shop. It is generally believed that Kean was 'discovered' in Teignmouth by Dr Drury, a former headmaster of Harrow School – or so Miss Emily Buckingham relates in the *Cornhill Magazine*. Kean performed a kind of ballet with his little boy – 'a little cherub of between three and four. He then acted Shylock 'in a surprising manner and lastly went through a pantomime as a most active Harlequin, and for doing this, or nearly the same, for four nights he received £7, his benefit included.' Since the actor married in 1808 this performance must have taken place about 1812.

There is a record of the piece played on the opening night of the theatre: It was a comedy *The Heir at Law*. This was followed by a farce *Of Age Tomorrow*. Boxes were advertised at 3/-, the pit at 2/- and the Gallery 1/-.

Soon after this another theatre, The Clarence, was built at the Bitton end of Coombe Vale Road at the instigation of Sir Warwick Tonkin of Rosehill Cottage. It was circular in shape so that it should be suitable for both circuses

and drama. In 1870 it still stood and adjoining it was a boys' school. A third theatre at the Quay, off Northumberland Place, was built on land given by Lord Courtenay. This was The Athenaeum. Its building cost £1,000. There was a theatre too, in Somerset Place – The Lyceum. This was later used as a boxing club. Obviously Teignmouth had too many theatres, because by 1825 the one in Station Road had become a coal store.

Coal, clay and fish were the main products traded from Teignmouth during these years. Records of the local families show that almost all were engaged in merchant shipping, fishing, or as coal or clay merchants. Every available square inch of space was used for the storage of coal so the degradation of a theatre to a coal store is not quite so surprising as it would seem.

Among other entertainments offered for the delectation of visitors was a skating rink in Station Road. This later became a stable and then a cheapjack ground where people congregated in large numbers in the evenings to listen to the vendors' patter and chat among themselves. In the first part of the twentieth century it was a police station.

There were public baths at the foot of the East Cliff. These were kept by Mrs Hubbard whose husband, Mr S Hubbard kept the Globe Hotel – later the

The Quays today

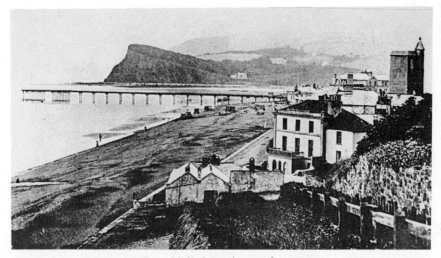

The baths at the foot of East Cliff, late nineteenth century

London Hotel – not to be confused with the Globe Tavern which was near the bottom of Globe Lane, now Sun Lane. (Mr Hubbard built the first sea wall). The baths were expensive – 4/6d per bath. There were reading and billiard rooms in the Assembly Rooms, 12 bathing machines on the beach – ladies to the left, gentlemen to the right – donkeys or horses for hire, coaches, jaunting cars, fives, cricket, football and bull-baiting and other amusements. The regatta, held annually, is believed to have been the first in England.

Building continued apace. Cockram's Hotel, now the Royal Hotel, was built in Den Crescent and private houses such as Woodway House, Rowdens, Mount View – later Hennon – now Yannon – The Hennons – later Treverven now Mount Everest – Hermosa House and Buckeridge House all went up about this time. Buckeridge House is now the White House and part of Trinity School.

Ferndale Road was called Lower Bugridge Lane and below it were two fields – Higher and Lower Paradise. The Paradise Tea Gardens there was a fashionable place to visit.

11 COMMERCE AND COMMUNICATIONS

In 1825 an Act was passed authorising the town to construct a bridge over the River Teign. The Act specified that the work be completed within three years. It was, in fact, completed in less. The bridge opened on 8 June 1827 and was a local marvel. It consisted of 34 arches of wood, was 1,671 feet long with a swing bridge to allow the passage of tall ships. To this day the swing bridge is opened once annually – usually on a September Sunday morning – to confirm the right.

The bridge company also purchased the ferry rights from Lord Clifford. The total cost of bridge, approaches and ferry rights was £26,000. The bridge company were forced to provide some means of crossing the river if for any reason the bridge became unusable: that was the thinking behind the acquisition of the ferry rights. An emergency of this nature did occur in June 1838 when the middle arches of the structure collapsed, having been eroded by shipworm. Traffic was not resumed until 1840.

Sir Alexander Gibb in his *History of Sir Thomas Telford* attributes the work to that gentleman and states that the Exchequer Loan Commission gave a grant of £8,000 towards its construction. Other authorities attribute the bridge to Roger Hopkins and this seems more likely to be correct.

Toll Houses were included at either end of the structure and the tolls raised in the first year amounted to about £1,000. The toll house at the Teignmouth side still remains.

The bridge partially collapsed again in 1893 and was finally completely rebuilt in 1931. On 28 October 1948 the structure was bought by Devon County Council and tolls were abolished. The purchase sum was £90,000. The ferry rights were not immediately included in the sale and for a while

The Teignmouth – Shaldon ferry today

these were owned by Mr W Powell of Okehampton, who bought them for an undisclosed sum. Eventually in 1952, they were purchased by Devon County Council for £3,500.

In 1820 it was decided to rebuild London Bridge; the stone used for the facing was to be Dartmoor granite. Accordingly, Mr George Templer of Stover built a granite tramway to facilitate the movement of stone from the quarries at Haytor to the canal which led to the Teign, down which it could be carried to Teignmouth. He also caused the New Quay to be built on reclaimed land, from which the ships could be loaded. When the project was completed he sold the quay to the Duke of Somerset who had business interests in the town. About the middle of the century the Duke sold the New Quay to the Earl of Devon who later sold it to Mr W Finch. The Duke sometimes resided in a house on the site of the present Methodist Church. The present South West Electricity showrooms cover his gardens. This land too, had been reclaimed at an earlier date. The remains of a boat was discovered in the foundations of Somerset House (Teignmouth) about 1850.

Road travel was improving; most roads were turnpikes. The Shaldon Bridge Company constructed a road linking Teignmouth and Shaldon when they built the bridge. There was a toll road over Haldon to Exeter – the toll shelter remains built into the road bank on the right hand side going towards

The New Quay, 1827

The toll shelter in Exeter Road

Exeter, a little before the road leading to the Golf House. There was no toll bar there. There was also a toll hut where the Coombe to Bishopsteignton road crosses the Teignmouth to Newton Abbot road. This was demolished fairly recently. Another hut stood at the foot of Woodway Road and is remembered by older local residents.

In 1846 the first train arrived at Teignmouth station. The railway had been built using Brunel's Atmospheric System. The fare to London was 17/4½d and the carriages resembled cattle trucks. There were no corridors or toilet facilities. The carriages were warmed by hot sandbags thrown in at each station, while hucksters, musicians and songsters travelled selling their services. The journey from Exeter to Newton Abbot took 45 minutes and cost 1st class, 2d; 2nd class, 1½d; and 3rd class, 1d. From London the journey took eight hours. Four trains ran daily between Exeter and Newton Abbot at a good speed. The motion was said to be 'exceedingly pleasant.'

From Dawlish to Teignmouth the line had to go through a series of tunnels because the cliffs came down steeply to the edge of the sea. A tunnel extended from the Dawlish Road end of Myrtle Hill to Teignmouth Station and another tunnel took the line from the station almost to Polly's Steps.

The trains were propelled by pneumatic traction. A pumping station remains at Starcross, part of a similar building is visible in the cliff at the east end of Dawlish Station. The pumping station at Wear Farm on the way to Newton Abbot has vanished, but it was situated close to the large pond by the bridge over the line. There was also a pumping station in Teignmouth. Within two years it became apparent that, although the atmospheric system had many advantages, the valves on which the maintenance of power depended quickly deteriorated in the salt sea air. Eventually the system had to be abandoned and from 1848 onward locomotives were used. The line was relaid as broad gauge and was protected by the building of a sea-wall extending from Hole Head to Teignmouth. Spray Point was constructed from a mass of rock debris which had fallen from the cliffs in 1839.

Railway sidings were laid at the Old Quay in 1851 when the town began to import quantities of coal; the coal quay, now used for clay and general exports, was built in 1887, Quay Road being opened in the same year to give access to the harbour.

The standard gauge railway line was laid in 1892. Tradition has it that Brunel rented a house in Teignmouth from Mr Tozer, while waiting for his house at Watcombe to be built.

The line between Dawlish Warren and Teignmouth has always been extremely vulnerable and has been breached by storms many times. In 1859 the *Illustrated London News* reported of Teignmouth:

Such was the terrific force of the impelled water that along the sea-wall and railway huge coping-stones, probably averaging one ton each, were tossed about like corks and huge fragments of the disjointed wall were rolled up on the metals. The breaking up of the structure is described as having been appalling: surf, foam and fragments of the debris rising in the air with a terrific roar. Through the tunnel which opens into the town the sea water rushed impetuously, flooding houses and damaging property to a considerable extent This and the retreating waves removing the ballast from the 'sleepers' of the rail, allowed the ponderous stones of the wall to bend and twist the metals in various directions. Of course traffic was for a while suspended although an inner line of rails (comparatively uninjured) used occasionally for shunting was utilised ... and communications speedily resumed.

The article was accompanied by an engraving taken from a photograph by Samuel Poole of the Devon Photographic Institute, Teignmouth.

In 1931 there was a landslip betwen Hole Head and Spray Point which blocked the line in both directions. In 1974 the line was breached both in Dawlish and Teignmouth, and in 1986 waves tore a hole under the track and sucked out the ballast near Hole Head tunnel. The line was closed for several days.

The railway below the cliffs, twentieth century

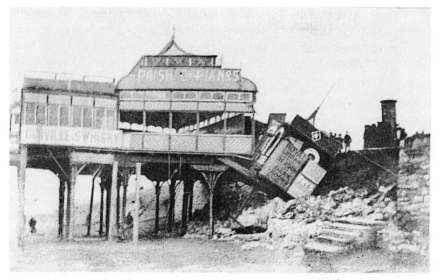

Storm damage to the pier

This is by no means a comprehensive catalogue of damage to the railway along the South Devon coast. Incidents occur with great frequency. The tunnels which led the line in and out of Teignmouth Station were removed during the last century since it was found that they acted as channels which increased the flooding in the town. A plan to take the line from Teignmouth Station inland, around Coombe, was finally scrapped after World War 2.

Contrary to what might be expected, the coming of the railway did not add to the prosperity of Teignmouth. It gave impetus to the growth of Torquay which, although on a branch line, steadily forged ahead after 1850. Whereas maps of the area in the early nineteenth century show Teignmouth in large letters and Torquay only marked as Torre in very small letters, by the end of the century Torquay was firmly on the map and much larger than Teignmouth.

In one respect, however, Teignmouth has never yielded to Torquay. The port has always enjoyed the larger share of trade and it is a source of local pride that the registration letters for fishing boats sailing from Dawlish and Torquay are TH – the first and last letters of the town of Teignmouth. In 1836 an Act was passed for improving the harbour of Teignmouth. This Act gave the town some degree of independence but it was not until 1853 that the port of Teignmouth, which until then had been a creek under Exeter, came into its own. This was greeted with great local jubilation since the townspeople had petitioned for the port to be freed over a number of years. There was a

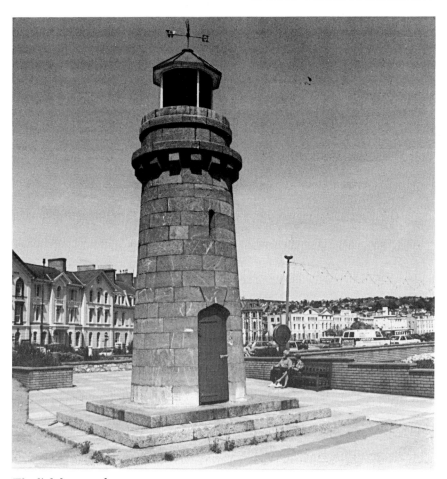

The lighthouse today

mile-long procession with banners marked 'We are independent.' A full-rigged brig, the *Minna*, was represented on a wagon drawn by two horses. The *Illustrated London News* reported:

> At twelve o'clock the Committee met and a Royal Salute was fired on the Den. A procession was formed headed by a Herald on a white horse supported by flag bearers: then followed sailors, the crews of various vessels, fishermen, gardeners, bands of music, magistrates, harbour and river masters, commissioners and other official persons: deputations of rope and sail makers, a smith at work with an anvil and a forge

97

in a cart, coachbuilders preceded by a chariot on a cart, maltsters with barley, plasterers with models of villas, builders and sawyers at work on carts: carts of wine and spirit, a cider merchant and a barrel, and model printing press and men printing the *Independent Port Journal,* a model railway and engine, companies of workmen and members of clubs and societies.

Prominent in the cortege was the full-rigged brig, *Minna,* on a cart drawn by two horses, manned by a crew, armed and labelled 'direct from Geelong with emigrants.' Also there was Captain Bartlett, captain of the lifeboat, with a model full-rigged ship and telescope: boats and vessels in various states of building, quarter-deck officers in full uniform, model steamers, an Indian ship and various curiosities. It was the most gorgeous display witnessed in South Devon since the passing of the Reform Bill.

The rules governing the new port stated that harbour commissioners were to be nominated by the two lords of the manors and other interested parties who were empowered to raise a loan of up to £15,000 and who took over the existing debt of £5,600. The rights of the owners of Stover and Hackney Canals were to be conserved.

The port handled a variety of goods. Imports consisted mainly of deals and wood pulps, but 40,000 tons of coal and culm (a forerunner of anthracite) were brought in annually. Culm had been imported for many years. The map of 1759 shows an area of Rat Island where culm was unloaded. Exports from

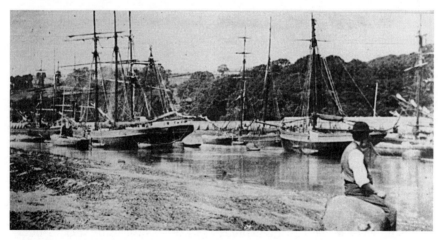

Teignmouth Harbour, 1883

one firm alone, Mssrs Whiteway, Watts and Co. were upwards of 30,000 tons of clay annually, while manganese, lead, iron and granite were also exported. In recent years the prosperity of the port has been based on clay.

Teignmouth Quay Company was formed in 1886. The directors included William Anson Cartwright (cleric), Pike Ward (ship owner), Messrs Scammell, Seale Hayne, William Hutchings and others. The Old Quay (formerly Rendles's Quay) was rebuilt and extended between 1800 and 1904 and access was improved. By the 1930s, as the result of world recession and World War 1, the quays were almost derelict. Devon Trading Company bought the shares and introduced some modernisation. Business improved until World War 2 when the area was used as a storage depot. Trade was at a standstill. After the war things improved. In 1968 United Builders' Merchants bought the company. In 1979 the company again changed hands being bought by Jeff Boyne and Kenn Dunn. It has now been sold (1988) to Associated British Ports (formerly British Transport and Dock Board); Jeff Boyne remains as Managing Director. In 1987 new offices were erected for the company on the Old Quay; the Old Quay Inn, a hostelry which had stood for some two hundred years, was pulled down.

Clay is still the major export. A side road to take traffic for the quays away from the road through the town was opened in 1972. In 1987, 253116.809 tonnes of clay were exported, and almost as much barley. Imports vary and include soya, coal, newsprint, maize, tapioca, pumice and cattle food. Total exports and imports fluctuate between five and six hundred thousand tonnes per annum.

The prosperity of nineteenth century Teignmouth demanded a town provided with all modern conveniences. The Teignmouth Town Improvment and Water Act was passed in 1835. In the following year the reservoir in Landscore Road was built. A further water supply was derived from Bitton Brook. By 1840 the whole of Teignmouth had piped water. The following appears in *Woolmer's Exeter and Plymouth Gazette*, of June 1838:

> Teignmouth: The company who have for many years past visited this delightful place will hear with satisfaction that the town is now abundantly supplied with water, and that it is conveyed to all the principal lodging houses. Persons, therefore, applying for houses this season will do well to ascertain this point as it so materially contributes to the comfort of every family The Subscription Band has commenced playing twice a week.

In 1885 Mr and Mrs James Wills of Oak Lodge gave a drinking fountain to the town. It was moved to the Little Triangle in 1918 where it can still be seen.

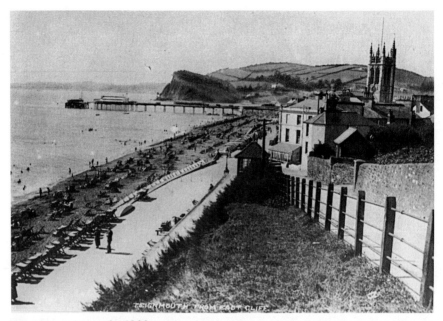

The pier as it was in 1900

The gas works were opened in 1839. There was a small gasometer in Lower Brook Street. Its remains were found during rebuilding in 1987. In 1850 George Hennet of Myrtle House offered land for an additional gasometer 'to warm the cells of the police station' at an estimated cost of £120 per annum. It was felt that a stove would suffice for the current winter and the offer was turned down.

Mr Hennet had been a contractor to Brunel supplying iron ware, rails etc. He settled in Teignmouth about 1840 and rebuilt Myrtle House (Alberta Mansions). He took a keen interest in local affairs and worked industiously to bring about the freedom of the port. His interests included ship-owning, the provision of tug boats and other maritime matters. He went bankrupt in 1853 and died not long afterwards.

Under the terms of the Act of 1835 Teignmouth was required to improve its streets. Many, especially Bitton Street, were considered dangerous. In Bitton Street the buildings from Clay Lane to Fore Street had to be set back to allow a street of at least 26 feet in width. Thirty three houses and several plots of land were compulsorily bought to bring this about. In 1859 the town came under the Local Government Board who became responsible for further improvements. In 1869 the Board bought the Den from Lord Devon and laid it out as a pleasure ground. The Point was acquired in 1890 and the whole of the front beach in 1905.

The Courtenays were the builders of the large houses (hotels) along the Front – Courtenay Place was built at the beginning of the last century and the Courtenay Arms can be seen on one of the houses opposite the Gun. Powderham Terrace was built in 1869.

To improve facilities for shipping the lighthouse was built on the Promenande in 1844/45 at a cost of just under £200. The Lucette Light on the Shaldon side of the river was set up in 1953 when Mrs Lois Lucette caused it to be erected in memory of her husband, Philip, who died in Teignmouth in 1949. The benefactress left £1,500 for the upkeep of the light.

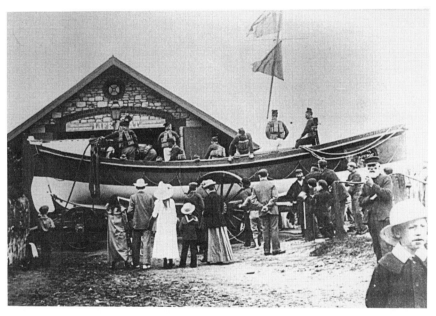

A lifeboat – the Alfred Staniforth – *and the lifeboat house* c. *1900*

A lifeboat was provided in 1852 and a fire service in 1863. There is some evidence of a private fire service earlier in an account dated 15 March 1818: '£27.12s.3d. paid to Mr Langley on balance for the fire engine.' In 1897 a steam fire engine was acquired at a cost of £400. There were 15 men in the fire brigade.

In spite of the improved water supply and general improvement in conditions in the town, there were several epidemics in the nineteenth century, not least the small-pox outbreak in 1829 and the cholera epidemic in 1860. Donkeys, which were the usual form of transport, left piles of dung in the streets, which were often left to rot. Many cottages had only one outside

101

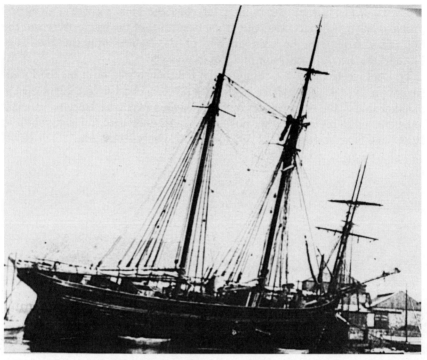

The Jehu: *owned by William Hutchings – a clay/coal trader*

earth lavatory between five or six of them and these were infrequently cleared. There was ample breeding ground for germs. In 1856 a cemetery was opened in Exeter Road at a cost of £2,500. This was needed to cope with the overflow from the churchyards. However, some families with large tombs continued to be buried in the precincts of St Michael's and St James'.

As one of the attractions of Teignmouth the pier was built in 1864 by Joseph William Wilson in conjunction with his eldest son. Mr Wilson later became President of the Crystal Palace School of Practical Engineering.

In the 1880s the pier was enlarged and by 1890 buildings had been erected on the seaward end. In 1930 the Devon Dock, Pier and Steamship Company sold the structure to Auto-rides of London. During World War 2 the pier was partly demolished – as a security measure. After the war, badly in need of repair, it was sold to Mr Brenner for £700. Storms have taken their toll of the structure – most of the seaward end has disappeared but an amusement centre still flourishes. During the 1930s it was port-of-call for pleasure steamers plying between Exmouth and Torquay.

In 1883 a market hall was erected between Brunswick Street and North-umberland Place and beside it were offices for the Local Board. From that time onwards Market Street was known as Old Market Street, and from 1900 as Teign Street. The market and town hall were destroyed by enemy action in World War 2 and their site is now used as a car park.

In 1894 the administration of Teignmouth was taken over by the Urban District Council. Mr William Hutchings was the first Chairman. The chain of office at present used by the Mayor was presented by Mr Hutchings'son, Ernest, in 1928. The medallion on the chain reads: 'He blew with His winds and they were scattered'. This relates to a medal struck in the time of Elizabeth 1 to commemorate the victory over the Armada. The scene on the medallion depicts two ships sailing out to sea. It has been suggested by the Museum Society that Teignmouth may have provided two ships against the Spanish.

12 THE OTHER SIDE OF THE COIN

The years of growth, the prosperous years of the nineteenth century: town improvements, fortnightly balls in the Assembly Rooms, a promenade around the thyme-scented Den, hot and cold public baths, in Carlton Place, the daily papers to read in Croydon's Royal Library, the local papers – *Teignmouth Post* (1882) and *Croydon's Gazette* (1849), the pier, donkey or sedan chair transport, jaunting-cars, coaches in and out of the town and mail delivery daily – Teignmouth had much to offer. A poem written in 1820 gives a clear picture of Teignmouth as Winthrop Mackworth Praed knew it:

> The buildings in strange order lay
> As if the streets had lost their way
> Fantastic, puzzling, narrow, muddy,
> Excess of toil from lack of study
> But still about that humble place
> There was a look of rustic grace;
> Twas sweet to see that sports and labours
> and morning greetings of good neighbours,
> The seamen mending sails and oars,
> The matrons knitting at the doors,
> The invalids enjoying dips,
> The children launching tiny ships,
> The Beldames clothed in rags and wrinkles
> Investigating periwinkles.

Praed said it all – or nearly all. He ommitted the other side of the coin – the stench of dried cod, the poverty of many of the townspeople. The Poor Law

had been revised in 1805 and some of the harsher conditions for relief abolished. No longer had a pauper to wear a 'P' on his sleeve and the initial letter of the town of his birth, but he was still required to return there for Poor Relief. Since often he must make the journey on his own two feet and the distance could be anything, many a pauper died on the way. The church registers are full of entries 'Vagrant – found dead in the street.'

In the nineteenth century poor relief was administered by a body set up by the local church – usually called the Guardians of the Poor. A rate was levied to raise the necessary money and often there were local charities which could help, such as the Risdon Charity in Teignmouth. Paupers could be housed in Poor Houses – maintained for the purpose, or they could receive outdoor relief. Those in Poor Houses were expected to work and contribute as much as possible to their upkeep. The infirm or elderly worked as long as they could and then were cared for by the parish. There were several small houses off Mulberry Street in Teignmouth, in Ponsford's Court, which were used for the reception of paupers. In 14 rooms, 17 adults and 23 children were accommodated. They received weekly pay – part of their earnings wherever possible – clothes and medical attention from the parish, but had to supply everything else themselves. The cost to the parish was 1/6bd gross, per head, per week. The accounts of the Guardians of the Poor of West Teignmouth show that, for the year ending Lady Day 1834, £158.3s.4d had been disbursed.

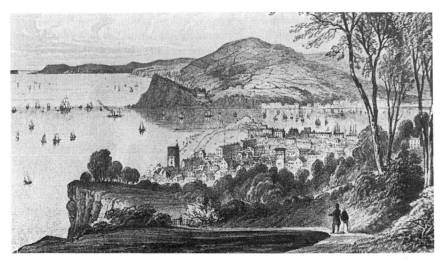

Teignmouth from the East Cliff c. 1850. Brunel's disused pumping station in just visible

Other entries in the accounts tell us that in January 1829 it was recommended that:

> John Caseley's pay be stopped,
> Boon's family be reduced to 4/- per week being able to work, the money due respecting Adam's child be enforced immediately, an examination of Sarah Gale be undertaken as to the father of her bastard child,
> Hall's family have 3d per week for 2 weeks before he comes out of Bridewell,
> Thomas Prouse to have a new shirt,
> David Davison to have one pair of drawers and one pair of stockings,
> a pair of shoes for Phillip Harris,
> Elizabeth Bovey to have a shift and Mortimore to have 4 oz of worsted to graft a pair of stockings

> *25 February 1828*
> the overseers to apply to the Magistrates at their next meeting to commit Mary Ann Pierce to the Bridewell for suffering herself to be gotten with child by Sam Bray, a married man with family

The Bridewell was the local prison, housed in part of the fish store. The iron bars over the windows remain. Mary Ann's sin was not in having a child out of wedlock, but simply that she had had a child which neither she nor the father could support and which was therefore a charge on the Poor Relief. Perhaps luckily, the child died so the resolution to commit Mary Ann was not put into effect. A Sam Bray is buried in a properous looking grave with headstone in West Teignmouth Churchyard. The dates are about right. It looks as though after an early indiscretion he became a respected tradesman.

During and after the Napoleonic Wars times were hard. Robert Jordan noted how the price of bread had increased and that people were eking out the flour with potatoes. He pointed out too that shell fish was an important part of the diet of the poor. It is recorded that in 1820 a widow in Starcross stood ankle deep in the Exe all day raking cockles to feed herself and her five children. Any surplus she bartered for bread.

At a meeting of the Vestry of West Teignmouth in 1820 it was decided that 'clothing be given in the Poor House but to no other', that 'Children above nine years old shall be employed picking oakham or any other work.' In 1836 it was decided to sell:

> the Messuage or tenenment some time since used as a Workhouse with the buildings and premises adjoining situated in Workhouse Lane,

West Teignmouth and to assign the five tenements lately used as Poor Houses ... for the remainder of a term of 3,000 years at an annual rent of 10 pounds ... the Work and Poor houses having been discontinued as Work and Poor Houses and no longer required for the use of the parish.

This, of course was not the end of Poor Relief – merely the discontinuation of the old premises.

The lot of the pauper during the nineteenth century was not an enviable one. He was clothed and fed – barely. People would turn their hands to almost anything to avoid going 'on the parish'. One Teignmouth man made a poor living catching stray cats and selling their pelts. It is said that skinned 'rabbits' were sold at a giveaway price in local butchers' shops. Other people smoked fish over fires on the beach and hawked their product around the houses of the rich. Women knitted socks and shawls from wool which they gathered and spun themselves – the wool being the 'knots' caught on bushes and brambles from the animal's coat. Sheep were still grazed on part of the Den.

Between the poor and the rich came the tradesmen. *Pigot's Directory* of 1823/24 lists in Teignmouth : 2 book sellers, 5 linen-drapers, 13 milliners, 4 tailors, 8 bootmakers, 5 bakers, 3 brewers, 3 confectioners, 7 grocers, 19 general merchants, 4 cabinet makers, 3 coopers, 2 ironmongers, 4 painters, 2 perfumiers, 2 tallow-chandlers,. 3 firms of attorney bankers, 5 auctioneers, 3 chemists, 2 physicians, 4 surgeons, and 7 academies (1 classical and 5 for ladies). One of the grocers was on the site of the present Lloyd's Bank and was owned by Mr Jones who specialized in 'Oopack' tea, which was very popular with the visitors. One of the iron-mongers was William Stooke of Teign Street and one of the physicians was William Cartwright. An auctioneer called Bickford lived in Bickford's Lane which was built at his expense. One of the tailors was Robert Gale who had a shop in the area now called after him, (Gale's Hill). Apart from the above-mentioned academies there was also a school for poor children run on the 'Bell' plan. (Few people were literate. The late Miss Kate Cartwright had a mason's bill drawn in picture language). There was also a Society for Educating the Poor of Newfoundland – many of whom were of Teignmouth descent.

Until the road to Newton Abbot was built about 1820 – through the influence of the Praed family – that town was usually reached by boat. Mary Heath, who lived in Mary Heath's Lane (renamed Queen Street on the accession of Queen Victoria) ran a ferry boat daily. She later became Mrs Davis, but continued to run the boat. Her good nature was such that she would miss the return tide and become stuck on a sandbank through waiting for a delayed passenger.

In 1817 the population of the two towns was 4,000 persons. *Croydon's Guide*

to Teignmouth for that year begins with a eulogy on the mild and equable climate. After a brief history of the town it states that the sea is gradually encroaching and:

> ... a brief glance must convince any observer that an accumulation of sand has buried cottages which once existed beyond East Teignmouth Church. [Almost certainly these were the ruins of the fish storage cellars]. The river has silted up and a shifting bar exists at its mouth. The depth of water on the bar at spring tides is 19 ft. Although the port has declined the town is thriving Although the rain falls plentifully, so well ventilated are the streets, so gravelly the soil that half an hour after a storm of rain pedestrians may walk about East Teignmouth without the fear of soiling their shoes The town is very healthy and the mortality rate is low. The canal cut by the late James Templer Esq. [Stover Canal] has drained the marshes and prevented those poisonous exhaltations which rising in the shape of fogs in times of yore, came down the river bringing with them pestilential miasmas Agues were so common before this sanitary ventilation of the fens that at Kings-teignton the inhabitants were scarcely ever free of them.

There was a contrast in the food eaten by the townsfolk: the poor ate shellfish and potato-bread and a little lard, the rich ate meat and game, white bread with butter, sugured cakes, all washed down with fine wines - or 'Oopack' tea.

Houses too, differed enormously. The small streets which clustered round the churches had cottages of cob or lath and plaster. The great houses were of stone or brick. A house recently gutted and rebuilt at the end of French Street was found to be a cottage within a cottage. The original tiny building had been enlarged simply by building a set of new rooms around it. It now forms part of 'the Very Small Shop'.

In West Teignmouth the great houses were Lower Bitton House (Praed), Westcliff House (Lord Exmouth), Winterbourne - built in 1842 (Rev. Page Richards); (the Rev. Page Richards of Winterbourne was curate of East Teignmouth Church and married the daughter of Sir John Strachan. His family remained at Winterbourne until the twentieth century); Hermosa House (Sweetland), Teignmouth House (to let), Brimley House (Bartlett), The Hennons – later called Trevernen, now Mount Everest – (Ermen), Mount View – later called Hennon, now Yannon Towers (Moir); Westbrook House; Brookfield House; Shute Hill House (Langley) and Beechcroft – built 1768 – (Macleod).

Brookfield House at Inverteign is now demolished except for the coach house and stables which are part of the Old House. The building is illustrated on page 155 of *Devon's Age of Elegance* (ed. Peter Hunt) and captioned 'A

dwelling on the banks of the Teign.'

In East Teignmouth there were Woodlands (Holland), Cliffden (Sir John Strachan); Eastcliff – built about 1830 – (Dr Tayleur), Rowdens (Babbage); Trafalgar Cottage (John Spratt) and the fine houses built along the Front by the Courtenay family – Courtenay Place (1805) and Powderham Terrace (1869); Myrtle House; Buckeridge House; Woodway House and Gorway (Whidborne).

John Spratt of Trafalgar Cottage had been a lieutenant with Nelson at the Battle of Trafalgar. His son, Thomas, about 1850, put forward an ingenious plan to stabilize the ever-shifting bar at the mouth of the Teign. At that time he was living in Mulberry Street.

Trafalgar Cottage, when first built, had a thatched roof and attic windows. There was a wide verandah with rough wooden pillars to support the overhanging roof. The gardens were stocked with rare trees and shrubs and had carefully manicured lawns. The house was burned down in 1915 and rebuilt in the present style. John Spratt died about 1820 and the house became the property of Admiral Tobin, son-in-law to Lord Nelson.

In the early 1850s Trafalgar Cottage was occupied by the Misses Baring Gould, aunts of the Rev. Sabine Baring Gould who wrote *Onward Christian Soldiers*. The Baring family had links with Bishopsteignton, the Goulds were lords of the manor of Lew Trenchard. The family conjunction came about in the eighteenth century. One of the Rev. Baring Gould's novels, *Kitty Alone*, is set in Combeinteignhead. In 1812 William Baring Gould, grandfather of the Rev. Sabine, rented seat No 3 in St James' Church for £21. His address is not known but he owned property in Bishopsteignton.

In East Teignmouth, too, was Minadab – at the top of Dawlish Road – now a restaurant. This house was built about 1820 by Robert Benjamin Young, a veteran of the Napoleonic Wars. The building was in the form of a ship, east aft, west fore, with rope ladders for stairs. It was named after his two small-ship commands – the *Minnow* and the *Dab*. From the cellars a passage is said to run underground to the beach: there is certainly a blocked-up doorway and the railway had to provide access to the shore by a bridge across the line. At the end of the century the house became the home of the Yardley family – perfumiers.

The Bella Vista Hotel was built about 1800 by Mr Burden as a private dwelling but was almost immediately converted to a hotel. Unsubstantiated tradition states that Jane Austen stayed there 1801/2. Esplanade House, on the site of the first Assembly Rooms, was used for a while as a private house and then became the Market House of East Teignmouth. The market cross stood nearby.

So much for the great houses and the great families. The common folk were usually fishing families – the Perrymans, the Drews, the Warrens, the Pikes

William Hook mending nets, 1938

and the Bellamys. All were engaged in the Newfoundland trade. The humbler Shimells ran pleasure boats, the Boynes hired out sedan chairs and did inshore fishing. The Hooks came to Teignmouth from Topsham about 1830 – two brothers and a nephew – James, William and Edward. They did whatever offered – fishing, sometimes building, but were basically a seafaring family. There were two Hooks in the crew of the first lifeboat, launched in 1852, and three Hooks in the crew of the Henry Finlay – the last lifeboat at Teignmouth. The family has been closely associated with the Coastguard service and at present John F L Hook is Auxiliary Coastguard-in-Charge. The Hooks have

lived in Ivy Lane since 1861 – at one time four out of the nine houses there were occupied by them. In 1941 three members of the family and two in-laws were killed by a direct hit during a bombing raid.

The Sealeys came to Teignmouth about the end of the eighteenth century. They too, were a fishing family. In 1986, Mr Harry Sealey, 32 Pennyacre Road, received a letter via the vicar of West Teignmouth from a Reginald Holwell living in Twillingate, Newfoundland. The writer wished to contact the descendants of Lydia Sealey who had lived at Teign Cottage, Teign Street at the end of the last century. He enclosed copies of letters sent by Lydia to his own ancestor - John Sealey - in 1874. The documents throw some light on the way family life broke down in the last century under the pressure of poverty and the collapse of the fishing industry.

> ... you cannot think of the joy it has given me ... to hear of your large family I have had as good as 20 [children] Your oldest sister Mary Anne is quite blind Hester is in Birkenhead ... has buried 3 children Your sister Harriet ... is married has got 4 and hope by the time I hear from you again to have one more. Her husband's name is Hamlyn ... Your brother Luke ... I have not heard from him for 18 years, but he is still out in Australia

Teign Cottage, Mrs Sealey's home in Teign Street has long since disappeared, but Mr Harry Sealey was born at 34 Teign Street – at the top of Scown's Lane – so possibly the cottage was in that area, especially if the lady's husband was a fisherman as her son almost certainly was.

The Chapman family came to Teignmouth no later than the eighteenth century. They too were fishermen and seafarers. The present Ernest Chapman, whose son, Tony, has a fishing boat, *Gerry Ann*, which fishes from Teignmouth in the sprat season, remembers his grandfather speaking about Teignmouth as it was in the days of his youth. 'Humble folk, they were you know, the Chapmans, and always fishing – but you couldn't make a living at it in those days.'

Between the 'humble folk' and the great families came the merchant traders and ship owners. The Ward family will not quickly be forgotten in Teignmouth. George Perkins Ward moved to Teignmouth after the Napoleonic Wars. He was a ship owner, ship insurer, Newfoundland fish salesman; you name it he was it. He lived in Terra Nova Place (now demolished) and later at 37 Northumberland Place. His name crops up in many places: buying a ship from Nicholas Mudge of Torquay, the *Jane and Susan*, to engage in the Newfoundland trade; prosecution of Henry Whiteway, pilot, for refusing to pilot his ship the *Ardent;* in trouble for selling bad fish; as Vice Consul for the Netherlands and Austrian Lloyds etc. etc. Ward was associated with Thomas

Pike, a member of another old Teignmouth seafaring family. (In 1583 a Thomas Pike is listed as owner of the *Elizabeth,* 20 tons, trading with Newfoundland.) In the nineteenth century Thomas Pike had deserted the sea and settled down to shore life as a butcher at 14 Fore Street (now demolished). Behind the shop he owned a few cottages – which stood until after World War 2 and were known as Pike's Cottages. Pike and Ward owned jointly a ship, the *Three Brothers,* a lucrative vessel. When George Ward's second son was born in 1864 he named him after his partner – Pike Ward. There were already three other children – Henrietta, Alice and Campbell. Overcome by a sudden access of religious zeal, Mr Ward had them all christened in 1864. Of the girls we know nothing, but Campbell Ward grew up to run a mineral water/ brewery which apparently prospered. He is mentioned first as living and working in Mere Lane - the brewery was behind Seaway House – later he lived at Luny House, in Teign Street, and towards the end of the century he moved himself and his business to Torquay.

Pike Ward seems to have spent his first years in his father's business but after the Sailors' Home and Institute was opened at 25 Teign Street (called Teignmouth House) in 1881, largely at the instigation of local ship owners who were concerned about the moral and physical welfare of sailors while in port, Pike Ward had offices there and is described as Lloyd's Agent. His mother, Mrs Perkins Ward, acted as a voluntary matron and it is said that she was both respected and feared by the men who frequented the place because of her fierce manner. She must have been a lady of determination and strong character because in later years when her son Pike was away on an Icelandic voyage she ran his business for him and was said to be the only woman shipbroker in the whole of Great Britain.

Pike Ward became a partner in the business a few years after his father's death in 1881 and became sole owner in 1895 at the time of his marriage. He was then working from 30 Teign Street – premises at the bottom of Scown's Lane – shared with John Scown. Early this century he moved to the Old Quay, to the present offices – the building which in its time had been used in turn as a store for Newfoundland fish, a prison and a mortuary. In 1948 the downstairs office in this building was still thriftily panelled with ships' doors from nineteenth century ships.

Pike Ward's wife died in childbirth and for this he blamed the child, his son, who was sent to live with relatives near Cowley Bridge in Exeter and so does not appear on the Teignmouth scene. The boy was named Edward Ardley Ward. There is one picture of him with his father taken when he was about eight years old.

In his early days (1914) Mr Ward lived at 16 Grove Crescent – the house had belonged to his father. As he prospered he moved to Valhalla in Upper Hermosa Road where the house still bears witness to his occupation: as

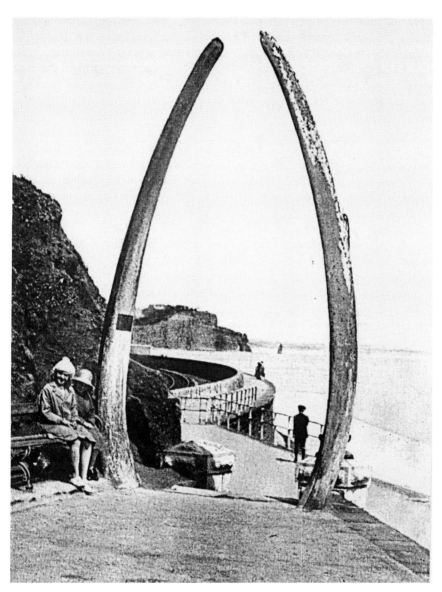

The whalebone arch at East Cliff

Vice-Consul for Norway and Sweden he gathered many Scandinavian arte-facts with which to decorate his home. The stairs are carved with Norse emblems and two carved wooden dolphins, which formerly decorated the front of Valhalla, can be seen on Dolphin Cottage, 32 Pennyacre Road.

After the death of Pike Ward in 1935 his housekeeper moved to the cottage and took with her the carvings. She commissioned a granite bird bath inscribed 'In Memory of Pike' for her garden. When she died the bird bath was scrapped but the dolphins have been restored by Mr Sealey, the new owner of the house.

A man not given to sentiment, Pike Ward was deeply concerned with his home town and its history. He was proud of his connection with the fish trade and in 1924 caused two arches of whalebone to be erected on that stretch of the Promenade then called Old Maids' Walk. (The Jubilee Shelter, midway between where the arches were situated, was the town's monument to the Jubilee of King George V). The further arch was removed by the Military to build a gun emplacement at the beginning of World War 2. The other arch rotted a year or two after the end of the war. Pike Ward also located and gave to the Catholic Church a pair of candlesticks and a portable altar used by the local Catholics during the years of repression.

Pike Ward was one of the original directors of Teignmouth Quay Company. Like his father, he had a finger in almost every pie but it is as a shipbroker and founder of the firm of Pike Ward he is remembered in Teignmouth.

After Mr Ward's death, Captain Toby, his partner since 1925, continued to run the ship-broking business until he retired in 1956. Ten years earlier Captain Toby had taken William H Jackson into the business as his partner. On the retirement of Captain Toby, Mr Jackson took over the business until his death in 1966, when Cyril Boyne and David Copeland became directors.

Another merchant trader of the nineteenth century was George Player. He traded mainly in coal. The *Teignmouth Post* of April 1897 bears an advertise-ment as follows: 'Direct Coal Supplies. Just discharged the *Nattala* and *Marie* with cargoes of Wallsend Coal. Due in a few days the *S R & H*, *Frances and Peter* with three cargoes. George Player.' Player began his business with sailing ships but went over to steam in 1897. The *Player* and the *George Player* were both colliers.

William Finch, another coal trader, was famous for his worn out ships which were known as 'the widow makers'. He bought up antiquated sailing ships cheaply and hardly bothered with repairs. In 1893 he bought the New quay from the Earl of Devon who had bought it from the Duke of Somerset. Mr Finch's most profitable boat was the *Eldra*, named after his home in Landscore Road. She was profitable throughout her life and when she was sunk by enemy action in 1917 her owner received adequate compensation. He died in 1929 leaving a fortune of £18,000. His son emigrated to Australia

where he named his gold workings Eldra.

The Bartletts are a family whose name occurs frequently in nineteenth century Teignmouth. Little is known about them except that they were surgeons and seafarers and intermarried with the Bickfords who built Bickford's Lane. A Mr Bartlett was a leading light in the rebuilding of St James' church. A Captain Bartlett played an important part in the procession celebrating the freeing of the port, and was captain of the lifeboat. The family are mentioned living at Brimley House from the beginning of the century until about 1870 when the Cartwrights moved in. There have been Bartletts in the town in the twentieth century but their provenance remains a mystery. The family tomb is in St James' churchyard.

The Tozers, an old Devon family, moved to Teignmouth from Newton Bushel (Newton Abbot) in the nineteenth century as notaries and attorneys. They settled at Cliffden on the death of Sir John Strachan, about 1845, but later moved to The Old Cottage, Dawlish Street. It may be that there were family connections in the town since the name occurs in West Teignmouth in 1663. About mid-nineteenth century they seem to have bought Eastcliff, possibly as a speculative venture, since in 1857 the land south of the railway was sold for building. In the present century an empty bell turret suggested that it may have housed the bell which Mr Tozer gave to the nuns of St Scholastica's Abbey in 1883 – but this is conjecture. Mr Basil Tozer went on the Grand Tour at the end of the nineteenth century and wrote his memoirs in an amusing fashion, but caused some embarrassment among the ladies of the town whose flirtations he catalogued.

Finally a family who were closely associated with Teignmouth but not of the town – the Shores. John Shore (1751-1834), Governor General of India, was the brother of Thomas Shore of Otterton who married Juliana Praed, youngest daughter of William Praed of Lower Bitton House. John was created Baron Teignmouth in 1798 – presumably he had other Teignmouth connections and his wife was Charlotte Cornish, daughter of a local physician. They had three sons and six daughters. The family left Teignmouth to live in Ireland where the last member died a few years ago. Three nieces of Baron Teignmouth, grandchildren of Thomas of Otterton, were well known and admired literary figures in the last century. It was the existence of Baron Teignmouth which prevented Edward Pellew from taking the title Teignmouth.

The Cartwrights came to Teignmouth about 1790 as physicians and surgeons. Later members entered the church. From about 1870 they lived at Brimley House. Miss Kate Anson Cartwright, last of the line, died at Abbeville, Winterbourne Road in 1959. She was a valued councillor, at both local and county level.

13 A SOCIAL CONSCIENCE

Because the nineteenth century was one of contrasts –the rich so very rich, the poor so very poor – thinking people became more acutely aware of their responsibilities towards those less fortunate than themselves: it was also a century of reform and social welfare. Laws governing the employment of children were introduced, the Poor Law was improved, libraries were set up and education for all was made compulsory.

Long before the Education Act of 1870 there had been schools for poor pupils financed by the Church or by private charities. There were also Public Schools and Dame Schools. In East Teignmouth the brothers Thomas and John Coleman left £110 – South Sea Stock – the dividends to be used for the education of poor children. Sir John Elwill and his son left £150 to be invested in 3% Consols for the schooling of poor children in East and West Teignmouth. This yielded £8.14s.7d, enough to pay for the services of a school mistress to teach 12 pupils.

A Catholic School was built in East Teignmouth in the early part of the century – situated at the bottom of Dawlish Street behind the present offices of Rodney Bennett. The building, which stood until 1987, accomodated nine pupils. After the Act of 1870 a larger school was built on adjoining land. It was used until 1967. In 1973 it was demolished to make way for the new road scheme. The Roman Catholic Primary School in Fourth Avenue was opened in January 1967.

The other churches too, had set up schools – usually Sunday Schools –from the late eighteenth century onwards. These were on the lines of Robert Raikes' school in Gloucestershire.

Weekday Schools – the East and West Teignmouth Parochial Schools – were built in Exeter Road, Teignmouth, in 1815 and rebuilt in 1859. The buildings still stand.

116

In 1902, A J Coles, better known as Jan Stewer, writer of stories in the Devonshire dialect, was temporary headmaster of the Exeter Road Boys' School. During his months there he collected material for some of his stories.

In 1911 West lawn School was built in Exeter Road behind the old school. At the same time two fields belonging to Miss Langley of Shute Hill House were bought for expansion. This school was later known as the County Secondary School and now forms part of Teignmouth Community College. The other part of the Community College, formerly the Grammar School, was built in 1920 to accomodate 300 pupils. It was later expanded to take 500. Part of the complex includes Winterbourne House and Mount Everest, formerly Treverven. The Winterbourne estate was bought from Miss Richards for the building of the school.

The County Primary School was built in Brook Street in 1879 as a single-storied building. The upper floor was added in 1904. Until 1911 it operated concurrently with the school in Exeter Road. A new primary school was built at Hazeldown in 1973 and the Brook Street school was pulled down. Infant and Junior schools have recently been built in Mill Lane to serve West Teignmouth.

It will be seen from the foregoing that the provision of educational facilities in Teignmouth has never been laggard.

One other school should be mentioned because of its value to the town and its historical significance. Trinity School was formerly the Convent of Notre Dame.

About 1826 the Redemptorist Order of Priests and Brothers bought a site on Bugridge Farm, originally part of the leper settlement of St Mary Magdalene. The farm lands stretched from Hazeldown in the north to Brimley Farm in the south. The monks, since Roman Catholicism was no longer illegal, built a monastery with a small public church and a private chapel. While the building was being erected they lived at Myrtle House on Myrtle Hill. In 1879 the monastery was completed and Myrtle House became a Redemptorist Guest house for a while.

One of the early Redemptorist monks was Bishop Coffin, Bishop of Southwark. He died in Teignmouth and was buried in 1885 in the little cemetary within the monastery grounds.

Within 20 years of its inception the monastery was felt to be too big for the Order, and it was offered for sale. Purchased by the congregation of Notre Dame it became a boarding school for girls in 1901. The school grew and became both a boarding and day school with a first class reputation. A new wing was added in 1930 and opened in 1931, and a gymnasium was opened in 1936. After World War 2 Buckeridge Towers was used for boarding pupils and for educational facilities. Soon afterwards, Oakley, an old farm house, was bought for use as a preparatory department and a domestic science room.

By 1977 the Sisters of Notre Dame were faced with the fact that the admissions to their Order were decreasing: not enough nuns were coming forward with the right qualifications to make the school economically viable. The parents of the pupils did not want the school to close and formed a trust to buy the school, which became known as Trinity School, and was both ecumenical and co-educational. The Bishop of Exeter and the Roman Catholic Bishop of Plymouth were patrons.

In 1984 the building was struck by the whirlwind which ripped through the town. Extensive damage was done to the structure. Recently Buckeridge Towers has been sold and demolished to make way for a new housing estate.

Roman Catholicism has always had a strong hold on Teignmouth. It was a fugitive from the French Revolution, Abbé le Prêtre, who celebrated Mass for Catholic emigrées during the repression at the end of the eighteenth century. After the Treaty of Amiens in 1802 the Abbé returned to France and Abbé le Verrier took his place. He remained in Teignmouth until 1814. In 1843 the Reverend Father Charles Lomax decided to make the town a Mass Centre where Mass could be celebrated regularly. Accordingly he hired a room at the Jolly Sailor Inn which had previously been used for secret Catholic worship. Mass was celebrated thereby Father Lomax on 3 April 1848.

The Jolly Sailor Inn today

In 1852 Queen Amelia, widow of Louis Philippe, stayed at the Royal Hotel and pressed for a Catholic Church to be built.

In 1854 the first Catholic Church was built over the tunnel on the Dawlish side of the station. Colonel Keating of Westbrook House donated a very fine stained glass window. The architects were the brothers Joseph and Charles Hansom of hansom cab fame. When the tunnel was demolished by the railway company the church was carried to Plymouth, stone by stone, and erected as Holy Cross Church in Beaumont Road near Friary Station. The present Catholic Church, dedicated to Our Lady and St Patrick, in Dawlish Road, Teignmouth, was built at the expense of the railway company on the north side of the cutting.

In the early part of the century, before the building of the Roman Catholic Church, French prisoners of war had been allowed to worship in a room at the foot of Mulberry Street. It is described as over some blocked-up arches, and its exact location is unknown.

The last seat of Roman Catholicism in the town was St Scholastica's Abbey, which closed in 1988 because the community had decreased to a point where it was uneconomic to continue the maintenance of the building.

During the French Revolution some nuns driven out of Dunkirk had settled in Teignmouth and founded a Benedictine Community. In 1862, with some impetus from Lord Clifford the building of the abbey commenced. It grew to be a beautiful house, in grey limestone banded with red sandstone. Countess English, sister of Archbishop English, living at Dunesk, Dawlish Road, gave part of her estate for the site. A chapel in the abbey was reserved for her private use and a communicating passage ran from it to her home.

The records of the abbey show that on 7 September 1883, 'the gardener of Mr Tozer brought a hamper containing a bell.' This bell was installed and rung daily except in the war years.

The last of the nuns has now gone into retirement and St Scholastica's is to be sold (at a price estimated at about six million pounds). The land will be used for various purposes including residential accomodation.

Zion Chapel, in Dawlish Street, was built about 1790, one of the earliest non-conformist churches in the town. It was pulled down in 1883 and replaced by the Congregational Chapel at a cost of £3,700. After World War 2 it became the United Reformed Church. It still stands.

Between the east wall of the church and Dawlish Street there is a tiny cemetery some six feet above the pavement. It is the remains of the old graveyard of the Zion Chapel. Originally it housed about 60 bodies; now only one tombstone remains upright, while four or five are fallen or built into the wall. The cemetary was disturbed and made smaller when Dawlish Street was widened and Myrtle Hill was reconstructed. The upright reads:

In Memory of
Joseph Boyd
Who died 28th November
1818
Aged 54 years
Also of Mary Boyd wife
of the said Joseph Boyd, who
departed this life 16th December 1820
Aged 59 years.

The Gospel Hall in Bitton Park Road was opened in 1840. Christchurch, Kingsway, and the Gospel Hall, Coleman Avenue, were erected just after World War 2. The Primitive Methodist Chapel in Chapel Street was built in 1876. Later it became the Wesleyan Chapel; it is now demolished. The Methodist Church, Somerset Place, was built in 1845 in the grounds of the Duke of Somerset's dwelling.

The Baptist Church, Fore Street, dates from 1865. The first church had been opened in 1824, but in 1832 the building was taken over by the Brethren Assembly leaving the Baptists without a place of worship for some 33 years. The new Baptist Church consisted of 21 members. The present church

Seine fishing from the beach

consisted of 21 members. The present Baptist Church was opened for worship in 1888 and cost £2,195.

The churches provided spiritual sustenance in nineteenth century Teignmouth, but something had to be done to provide food for the starving. In 1851 a soup kitchen was set up in Willey Lane. It was rebuilt in 1887 at a cost of £150 and continued to function until the end of World War 1. The kitchen was supported entirely by voluntary contributions and was open throughout the winter months. It was felt that in summer, food was more plentiful in the form of shellfish and suchlike. Dinners were provided for the very poor completely free and there were vouchers for bread and coal. Children's dinners cost one halfpenny.

Some local people remember going to fetch the soup – which was always pea – in quart jugs. As the receptacles were filled the soup dripped over the ledge of the window which was the serving hatch. As it cooled the soup formed a crust which could be scraped off by hungry children, providing a free mouthful. The soup was 1d. per quart and was described as 'exceedingly nourishing'. The Soup Kitchen Trust Fund is still in existence.

When Mary Risdon died in 1718 Lower Bitton House was given to the poor of Teignmouth and its rent was distributed by the churchwardens of St James'. At a later date – sometime in the nineteenth century – the house and lands were sold to the Praeds for the sum of £180. This money was invested to bring in an income allowing 10 shillings a year to be given to each of 21 poor spinsters and widows who receieved no other poor relief.

Julia Cousins, who died in 1890, left money invested to provide a charity for single women, over 50 years old, with an income of no more than £50 per annum, who were born in Teignmouth. She nominated the first annuitants – one was to receive £20, the others £10. The Trust still functions but the terms of the charity have obviously had to be amended since the qualifications have become unrealistic.

The social conscience of the nineteenth century did not forget the sick. The earliest medical services were provided by monks who were trained in the use of herbs and elementary physiology. Additional help was offered, but frowned upon by the Church, by 'wise women' who, with a knowledge handed down from generation to generation, prescribed or mixed potions for the sick.

In the sixteenth and seventeenth centuries barbers performed the duties of surgeons – especially blood-letting. Until 1700 both Teignmouth and Dawlish had no real medical services. In 1741 the Royal Devon and Exeter Hospital was opened in that city. At about the same time 'physicians' are noted in Teignmouth and Chudleigh. The Cartwrights were among the earliest healers in West Teignmouth. The treatment of patients was still very casual and they were cared for in their own homes.

In 1848 an infirmary was established on Myrtle Hill, largely by the efforts

of Dr F Leman of Teignmouth and Dr F Knighton of Dawlish. The building provided beds for eight patients and was erected over the railway tunnel leading to the station. In 1852 the infirmary and a similar institution in Dawlish were amalgamated and given the name of Teignmouth and Dawlish Dispensary and Marine Infirmary. It gave free in-treatment to the poor on the recommendation of a minister or parson, and was financed entirely by donations. In 1860 the West Teignmouth Dispensary (site unknown) was united with the Infirmary. On the bankruptcy of George Hennet in the early 1850s, Myrtle House (later Alberta Mansions) came on the market. At that time the Redemptorist monks were living there. The house was leased by the infirmary and sub-let to the monks and others. Since the rent paid by the infirmary was only £35, the sub-letting produced a good income. In 1880 the monks moved to Buckeridge Road and shortly afterwards the property was bought by the infirmary and used for the housing of patients. An extra ward was added in 1887/88 for male patients. The cost was £500. In 1896 the name Teignmouth Hospital was adopted. Records for the following year show that the hospital cared for 1,600 out-patients and resident sick.

An isolation hospital was erected by the Teignmouth Port Sanitary Authority in the grounds of Bitton House in 1905; it still stands – a red brick building near the bowling green. The structure cost £2,600 and had beds for eight patients which came from both the port and the urban area. The number of beds was quickly increased to 20. Sufferers were carried to the institution in a double-ended wicker contraption which was pushed along by a porter and known as 'the parish chair'. Local residents remember how matron stood at the door to receive gifts for her patients and to hand out their dirty linen.

There had been a dispensary and fever hospital in West Teignmouth for some years before the opening of the one at Bitton House but no details are known of it. In 1880 the townsfolk had petitioned the Medical Officer of Health 'for a conveyance to carry patients to the infectious disease hospital.' Until that date sufferers had to walk or depend on carriage by friends or relatives. The parish chair was the result of the petition.

The town was regarded as remarkably healthy. In 1916 the combined ages of 11 persons living in the small area of Saxe Street totalled 928 years.

The hospital in Mill Lane replacing the one in Alberta Mansions was opened in 1925 at a cost of £17,000. Lady Cable, who throughout World War 1 had allowed her home, Shute Hill House, to be used as a sick bay for the services and had nursed there herself, performed the opening ceremony. The new hospital had two general wards of ten beds each (one ward for each sex), four private wards - one double bedded and three single, an operating theatre, X-ray apparatus and other 'modern appliances'. Its use was quickly appreciated for six years after its inception it was caring for an average of 103 in-patients and 723 out-patients per annum.

Between the two World Wars plans were made for a 100 bed general hospital to be built at Holcombe to serve Teignmouth and Dawlish but World War 2 put paid to that.

Teignmouth Hospital was bombed on 5 May 1941 and three nurses – Olga Bruns, Muriel Taylor and Mary James were killed, also seven patients. Emergency premises were found in Hermosa Lodge, Hermosa Road.

After the war considerable pressure was exerted for the rebuilding of the hospital but it was not until 19 March 1953 that the foundation stone was laid by Dr Ross Kilpatrick, a local physician. In order to obtain permission for rebuilding, the hospital was planned as a maternity unit since in this department it was easier to obtain the go-ahead. Much of the credit for the building must be laid at the door of Mr Theodore Edwards, local solicitor, who exercised an unrelenting public pressure on the Minister of Health.

On 26 September 1954 the new hospital was opened by the Rt Hon Iain Macleod, Minister of Health. It was the first complete general hospital to be built in Britain following the inception of the National Health Service in 1948. Miss E Colley was Matron. At that time (1953) there were 32 beds in four main wards, two private wards and a children's ward. Later the children's ward was discontinued. There are now 38 beds.

An undamaged part of the old hospital has been preserved in the Physiotherapy and Radiography Departments which equipped by the generosity of the League of Friends was opened on 25 October 1978.

14 INTO THE TWENTIETH CENTURY

The last century ended with some excitements. There were the jubilees of Queen Victoria in 1887 and 1897. Trees were planted on the Ness, which had become defoliated in recent years, to commemorate the Diamond Jubilee. Then there was the outbreak of the Boer War in 1899. The death of Queen Victoria in 1901 – a sad day for England – ushered in the new century.

The tonnage cleared by the Port of Teignmouth in 1897 was 122,110 tons. Coal was the major import and clay the major export. There were 44 registered fishing boats employing 275 men and boys, 21 merchant vessels and two tugs – the Regia and the Teign. The former belonged to the Regia Steamship Co., of Regia House, the latter to the Harbour Board. When incoming ships appeared on the horizon both tugs raced to catch their custom. Given even odds the Teign always won. The Regia was sold in 1915 and the Teign in 1924, the Tug Company dissolved in 1931.

Three shipbuilding yards operated in the town – Owen's, Potter's and French's. The jadoo factory on the Old Quay still made Teignmouth thread.

The population of the town was, in 1871: 6,700 persons; in 1891: 8,292 persons; in 1901: 8,499 persons; in 1931: 10,197 persons; in 1961: 11,528 persons; in 1981: 11,995 persons and today (1988): 13,257 persons.

The strategy of the twentieth century has been to expand the tourist trade. For the amusement of visitors and residents a bowling green was laid out on the Den in 1909 and tennis courts were made in 1910. Bitton Park was made into a pleasure ground in 1906 at a cost of £3,500. The boom years for the tourist trade were immediately after the last war when everyone wanted a holiday and there was little foreign competition. Since then, competition from overseas and from the coastal towns of Cornwall has taken its toll.

Fishing is now a minor industry. A small whaling fleet was disbanded in the 1930s. An upsurge in deep water fishing from Teignmouth in the 1970s was short-lived. Most of the locally registered boats now sail from Brixham where the harbour has a deeper draft and a market is available. Ten seine boats are engaged in salmon fishing and the collection of shellfish and three boats sail from Teignmouth for inshore fishing. In all about 35 men are engaged in the trade.

The Fishermen's Beach as it is now

World War 1 disrupted the town's development as a seaside resort and dealt blows to the fishing industry. Local fishing for sprats and whiting survived until the 1930s. Even now two boats are engaged in the trade.

Belgian refugees who took shelter in Teignmouth during the war gave a small garden to the town as a token of their gratitude. It now lies just below the pier by the bowling green.

Model Cottages in Daimond's Lane were built towards the end of the nineteenth century for rehousing. During World War 1 the tenements were used as billets for troops and so gained the name of The Barracks.

Communications by road have greatly improved as the century has

progressed. Since World War 2 the new motorway linking London and the Midlands to Exeter has brought both places much nearer.

In 1929 Mr Parkhouse of Agra Engineering opened a small aerodrome on Haldon. From it aeroplanes were sold and prospective buyers were given instruction in the art of flying. In 1933 an air service flying twice daily from Cardiff to Teignmouth to Plymouth was inaugurated. The total time taken – Cardiff to Plymouth – was 55 minutes, and the planes were chartered by the Great Western Railway. An airmail service began but was discontinued almost immediately. Mr Parkhouse left Haldon to take over the management of Exeter Airport in 1937. Haldon Aerodrome continued until 1939 when it was closed on the outbreak of war; it has never reopened. Airports at Exeter and Plymouth now provide air links with the Continent and facilitate inter-city travel at home.

The last of Teignmouth's shipbuilding yards became derelict in the early years of the century and Mr Morgan Giles bought it from the owners, Gann and Palmer, in 1921. The new ownership gave the yard new impetus. It prospered for many years and was a major source of employment in the town.In peacetime it built pleasure boats, yachts and cruisers; during World War 2 it built air-sea rescue pinnaces, motor torpedo boats and other small wartime craft. The yard was used by the Americans as a repair base. All this coming to the ears of German Intelligence caused Teignmouth to suffer more than its share of bombing by enemy aircraft.

Between 7 July 1940 and 29 May 1944, 81 high explosives and 830 incendiary devices fell on the town in 21 raids. Among the worst raids were as follows: 13 August 1942, in the early evening, when eight high explosives killed 14 persons, seriously injured eight and slightly injured 34; 16 houses were destroyed. The bombs fell on Myrtle Hill, Barnpark, Higher Brimley, Parson Street, Northumberland Place and Shaldon. In this raid the town hall and market were demolished. On 10 January 1943, in the early afternoon, seven high explosives killed 20 persons, seriously injured six and slightly injured 22; 21 houses were destroyed. This raid covered Powderham Terrace, Alexandra Terrace, Saxe Street, Bitton Street and Salisbury Terrace. Two hotels which stood on the Gun were entirely demolished.

Clearly the Germans were intent on destroying the shipyard and breaking the rail link between Exeter and Plymouth. The line is especially vulnerable at Teignmouth. It is remarkable that they were unsuccessful in both aims. However, they did not concentrate only on those two targets. Planes flew low over the town, raking civilians with cannon and machine-gun fire. In all, 88 residents were killed, 228 wounded and about 300 houses totally destroyed.

After the war the bombed sites of Lower Brook Street, Bitton Park Road, Powderham Terrace and Northumberland Place remained for several years as sad reminders of what had gone before. As in 1700, Teignmouth had to be

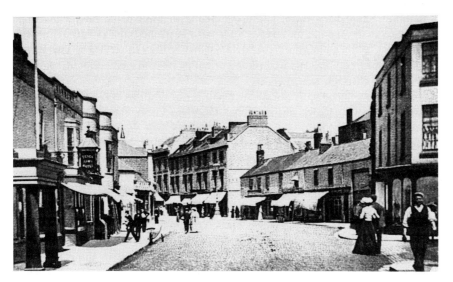

Northumberland Place, Teignmouth, c. *1910*

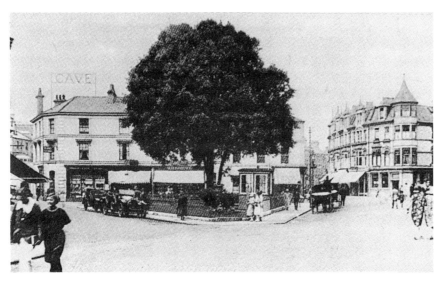

The Triangle, Teignmouth, c. *1925*

127

rebuilt. It was decided to use the necessary demolition to improve the town. The flats and maisonettes in Bitton Park Road were the first to go up, winning a national award for design. Council housing in Fourth Avenue, Hutchings Way, Coleman Avenue and Jordan Drive was pushed ahead and Kingsway became a site for an army of prefabs. Gradually the old streets below Bitton Park disappeared. The last was pulled down in 1972 to make way for the dual carriageway through the town.

From Exeter Road, just above the Community College, a road has been cut across Landscore Road, through the Groves to join the main road from Newton Abbot at the bottom of Gloucester Road. At the time of writing this road is the centre of much controversy since there have been so many accidents at its foot.

Between 1974/78 the stretch of road from Gloucester Road to Bitton House was widened and straightened. The corner of Coombe Road was cut back and flower beds planted. In East Teignmouth, Eastcliff was pulled down to make way for a coach station: the coach house remains.

With the advent of better roads and the popular use of the motor car, the town has grown steadily since World War 2, becoming, to some extent, a dormitory town for Exeter and Newton Abbot. New estates have mushroomed on the outskirts – on the Maudlin lands and Higher Holcombe Fields. The grounds of the great houses such as Ashleigh and Hazeldown have been built over and the houses pulled down. Between 1946 and 1972, 1,939 houses were built – 633 by the local authority and 1,306 by private enterprise. The rate of building since 1972 has barely decreased.

Four blocks of flats – Douglas House at the top of Saxe Street, named for Councillor Douglas Chapple, Pellew House off Teign Street and two blocks in Parson Street – were erected mainly for people displaced by the road building scheme. Flats for old people have been constructed in Speranza Grove, Second Avenue, Saxe Street and Bitton Park Road. Sheltered housing is provided at Quinnell House (named for Dr George Quinnell) in Bitton Park Road, Alberta Court and St Mary's Court. Private sheltered accomodation has recently been opened by Abbeyfield and Spiral Housing in Heywood's Road. Beechcroft in Shute Hill, the eighteenth century home of the Macleod family, was demolished in 1964 and is now a Devon County Council home for old people.

The Alice Cross Day Centre for old people, which after World War 2 used a site at the bottom of Daimond's Lane, is now housed in a purpose-built building in Bitton Park Road. Miss Cross, still a very active worker at the centre at the age of 93 years was awarded the British Empire Medal in 1974 for her work with the elderly which began in 1943. The centre has been endowed by several benefactors of whom Winifred Enefer of Shaldon was the most notable. Old people of Teignmouth and Shaldon can use the centre freely and

for a small annual fee can join in the activities provided by the Social Club.

In 1956 South West Electricity had a minor disaster. A wooden lamp standard collapsed and by domino effect all the standards in the centre of town came down.

In 1974 the new Local Government Act brought Teignmouth under the administration of Teignbridge District Council, and the town was able to realise its long held ambition to have a mayor. Edward Card was the first to be elected to this position. A new police station was built in Carlton Place on the site of the Carlton Cinema which burned out in the 1950s.

In 1967 the Council modernised and improved the Pavilion on the Den and it became known as the Carlton Theatre. It is now run by the Teignmouth Players – an amateur dramatic company which provides live entertainment for both residents and visitors.

The Teignmouth Town and Maritime Museum (open from May until the end of September) was opened in 1978. It houses an excellent collection of artefacts which illustrate the life of the town over the ages. Of particular interest are: the Domesday entry, the model of the Bitton estate made in 1863 and the objects removed from a wreck found off Church Rocks.

The site of the wreck which was discovered by a local lad, Simon Burton, who was 13 years old at the time, has been designated an official historic wreck site (1977). Its investigation by the Burton family and Dr Margaret Rule (Director of the Mary Rose Trust) will continue. Some cannon and a quantity of shot have been recovered and also cooking utensils including a copper cooking pot with a jug handle, a copper caulking boiler and various other items. The ship appears to have been an armed supply pinnace to the ships of the Armada although there have been various theories about its identity. More work will have to be done before there can be a final judgement.

On the grass outside the Museum is a rope-anchor dating from approximately the sixteenth century. Nearby is the foundation stone of the new railway station which was built in 1893, a turnpike stone from Bitton Park Road, and the foundation stone of the East and West Teignmouth Parochial Schools.

The new Public Library was opened in 1973. The service had used temporary buildings since the destruction of the original building in World War 2.

In 1968 Morgan Giles' shipyard closed down, not long after Donald Crowhurst set out on his ill-fated voyage. Crowhurst sailed from the yard in the *Teignmouth Electron* taking part in the Sunday Times Round the World Yacht Race. He was ill-prepared. Later his boat was found abandoned. His log had been falsified: Crowhurst was adjudged lost at sea.

The town has always suffered from flooding, since the Tame bringing down

Teignmouth front today showing pier and war memorial

excess water from Haldon is sometimes held back by the volume of water coming down the Teign. The sea-wall, too, has been breached on numerous occasions. Since the last war extensive work has been undertaken to prevent flooding by the sea. The Promenade has been sloped outwards to facilitate drainage, groynes have been placed along the beach to prevent the erosion of sand and the sea-wall has been made convex in order to throw back the rush of water. The whole scheme cost £85,000.

Flooding by the Tame is more difficult to circumvent. Excess water is drained off along Lower Brimley and emptied into the sea by the Litterbourne exit. Even so sandbags are still regularly placed over doorways in the lower part of the town whenever high winds and heavy rain are likely in conjunction with high tides. There was extensive flooding in 1924, again in July 1939, when there were two feet of water in Station Road and boats had to rescue shoppers from Woolworth's Stores; in 1960, 1974 and 1980 French Street, Lower Brook Street, Station Road and Teign Street were badly flooded. In 1984 the town was struck by a whirlwind which did much damage.

The Tame is now entirely underground but still plays an important part in the life of the town, not only as the town's main sewer. In many places the culverting is weak and it is not unusual for a startled householder to find a deep hole filled with swirling brown water at the bottom of his garden.

Holes too, or rather tunnels, have appeared on the Ness, in Bitton Park

Road in Yannon Terrace - their purpose has never been truly explained. It is likely that the two in the town were water courses. There are wells all over the area. When Clifton House*, an eighteenth century building, originally known as Mear Plot House and at one time used by the curate of East Teignmouth was being renovated a well and a tunnel were found in the foundations.

The tourist industry remains the mainstay of Teignmouth, but the number of hotels has decreased. Many have become retirement homes for old people and some have been converted into flatlets for self-catering holidays. New industrial sites are now situated at Broadmeadow and in the station goods yard. There are caravan and camping sites at Holcombe, Wear Farm, Wakeham's Field, Coast View and Crownwell, the last three at Shaldon.

Today's typical Teignmouthian was born in the Midlands or London, but has settled into the age-old life of the town. No longer does the Devon accent predominate – it is, in fact, rarely heard. The old families have died out with a few exceptions.

Where Teignmouth will go from here is difficult to predict. The life of the town will change – as it has constantly over the ages. The only certainty is that Teignmouth will remain. Bloodthirsty Saxon, marauding Dane, calculating Norman, invading Frenchman and dedicated German have not destroyed its spirit. These streets have been trodden by barefoot paupers, ladies in silk slippers and pattens, rank-smelling fishermen and perfumed dandies. All have left something of themselves here – as we shall, who live here today.

* Clifton House was destroyed by fire, spring 1989.

Appendix I
RINGMORE, SHALDON AND LABRADOR

The village of Shaldon is itself a comparative newcomer on the South Devon scene, but Ringmore is much older than Teignmouth and possibly older than Bishopsteignton.

Ringmore, derived from the Celtic *Bryn Mawr* (Great Hill), traditionally had a church before the Saxons were established in England. A Saxon font was discovered there during the last century which proves its existence in Saxon times. For many years the red sandstone bowl had stood in the graveyard, near the porch, but in 1881 it was recognised and restored by Major General Chermside and fitted to a modern base which is inscribed 'To the glory of God this ancient font was restored and replaced by Henry L Chermside and Josephine his wife MDCCCLXXXI.' It is likely that an early settlement in the area, which was far enough from the mouth of the the River Teign to offer protection from raiders and surrounded by hills, declined before the Norman conquest, although the church remained as a chapel for fishermen. It certainly had fishing connections since the edifice is dedicated to St Nicholas of Myra - the patron saint of fishermen.

Before the Normans came to England, *Rumor*, (the Saxon name for Ringmore), belonged to a Saxon thane - Brictric Meau of Gloucester. After the conques the manor passed to Baldwin, Sheriff of Devon. At the time of the Domesday survey it was held by Stephen, Lord of Haccombe, and then by devious ways it came to the Carews. Thomas Carew sold it to Lord Clifford of Chudleigh in 1671. There is some evidence that the manor was by no means impoverished. In 1316 the king had demanded of it 'one man at arms' - not a big price to pay perhaps, but enough to show that a hamlet existed and was rich enough to provide the king with some part of the sinews of war. Polwhele, writing in 1795, is ignorant of its ancient history and speaks of the church and a chapel built in fairly recent times by the Carew family. In this he is mistaken: it was rebuilt by the Carews.

> In our way to the Chapel of St Nicholas we pass Rinmore or Ringmore, delightfully situated a quarter of a mile from Shaldon. Proceeding by the side of the water we reach the church or chapel. This structure is supposed to have been built about 120 years since by the ancestors of Sir Thomas Carew of Haccombe. It is said to have been beautified in 1745. It measures about 44 feet by 14 feet. In 1790 was laid the foundation of a new aisle running out from the north side, 31 feet by 16 feet.
>
> St Nicholas was, as is reported, formerly annexed to the living of

Haccombe and subject to the Arch-priest of Haccombe who performed all the parochial duties there. But since the chapel was built at St Nicholas it has been served by a curate formerly nominated by the Carew family but now by Clifford. We do not know that a clergyman hath been possessed of St Nicholas by institution but it hath been always reputed a curacy. The first clergyman who held it under sequestration was the Rev. George Sandford, Rector of Stokeinteignhead who took out the sequestration on the death of Mr Strode the former curate, unknown to Lord Clifford. Mr Elias Carter who succeeded Mr Sandford held it by nomination from Lord Clifford as well as under sequestration. His nomination dates from 1720 Mr Carter commonly served St Nicholas once a fortnight one part of the day, though before his time it was served but once a month The value of St Nicholas doth not amount to a full £7 per year; in the king's book certified value £8.

A clue to how the area had decreased in ecclesiastical (and probably commercial) importance occurs in the term 'arch priest'. This is a very old title and denotes an incumbent who before the Reformation would have had several priests under him. The arch-priest at Haccombe held sway over six priests: his church and parish were large – and of ancient foundation. The number of sub-priests allocated to an arch-priest was dependent on the number of chapels he served. It is therefore likely that in pre-Reformation times the arch-priest of Haccombe served six chapels, and Ringmore was one of them. At the present time there are only two arch-priests left in England – and the Vicar of Haccombe with Stokeinteignhead is one.

Beatrice Creswell (1902) mentions 'a little font, of no architectural merit, but inscribed with the wardens' names and the date 1630' which was 'cleared away' when the Saxon font was restored by General Chermside. She records that the Rev. Marsh-Dunn said that the little font had been given to some mission chapel or other but he could not remember which.

In the early years of the twentieth century the church is described thus:

It had no architectural pretensions. There was a little south porch with a sundial over it, a bell turret with a wooden spire. All the exterior used to be rough cast and whitewashed and a clumsy external stairway led up to the galleries. Alms were collected at the gate of the churchyard from those who came down these stairs. Inside the galleries ran round three sides of the church, and a large 'wing' (which cannot be designated with the architectural term 'aisle') at the north obscured all traces of the original chapel. Pews choked the entire space almost concealing the altar

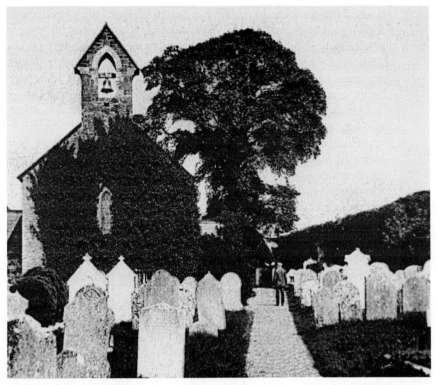

Ringmore Church, 1924

Cleared of all mortar and whitewash, the red stone of the building is now displayed inside and out. A small new bell turret surmounts the west end. The incongruous north wing has been removed and the building now comprises a nave and sacrarium, a doorway on the north leading into a new vestry. Formerly there were steps into the church. The floor has now been raised and paved. (This is not wholly satisfactory as it brings the level of the east window very near the floor). All the main features of the building are of the 13th century, the lancet windows being very plain with very deep splays, the east window having five lancets under a hood-mould. Among the discoveries made on removing the plaster was a circular 'lowside' window on the north east. This of course has been described as a lepers' window and to emphasize the error it is filled with stained glass representing a leper receiving the Sacrament. As a matter of fact, when examined from outside the window is of such elevation that a leper could hardly have looked into it.

A circular-headed piscina with a shelf was discovered, now sup-
plemented with modern sedilia. On the north side is an aumry. The
walls of the sacrarium are panneled with marble, and at the time of the
restoration described, the stone altar was set in the church

Two of the more interesting memorials in the church are:

James Mardon Brockington, who died on his passage from
Sierra Leone to London. 14th October 1832. Aged 39 years.
But though his body in the deep doth lie
His soul we trust is with our God on high.

[The family name 'Mardon' relates to a family who were prominent in
Teignmouth in this and the last century. Mardon House, West Brimley,
Teignmouth, still bears their name.]

and

This tablet is erected by the afflicted parents to the memory of an only
child, James Brockington Hore, 21 years of age who was drowned
while bathing in the river that flows by these walls August 13th 1858
....

The church register dates from 1616.

The ferry crossing from Teignmouth to Shaldon has been in existence from
time immemorial and no doubt there was a small inn or resting place on the
Shaldon side which corresponded to the Ferry Boat Inn (Jolly Sailor Inn) at
Teignmouth. A few fishermen's cottages grew up around this spot and as
times grew more peaceful the fishermen of Ringmore gradually moved nearer
the mouth of the river. Shaldon is mentioned in Chancery proceedings in the
early seventeenth century and a ship from St Nicholas is mentioned in the
complaints about the Flemish boats entering Teignmouth harbour in 1625.
Shaldon is also mentioned in connection with Brief of 1690. It is probable that
St Nicholas was used to cover both hamlets in the seventeenth century, but by
1690 Shaldon was large enough to have an identity of its own. The Carews of
Haccombe built a hunting lodge about 1650 between Ringmore and Shaldon
and when Lord Clifford bought the manor he continued to use it for the same
purpose. The building still stands - facing the end of Bridge Road. It has been
used as a restaurant and then a shop.

There are some old cottages in Shaldon village which date from the late
seventeenth century - Wyche Cottage is one of the quaintest of these. The
whole residential area is crammed between the steeply rising land towards

135

Torquay and the foreshore: the result is a maze of unplanned streets with houses piled one on top of the other, many of them extremely small. Much of the land on which the village is built has been reclaimed. A wall built from the end of Albion Street to the far end of St George's Field keeps the water from Fore Street and Ringmore Road. Like Teignmouth, Shaldon had its Poor House; this was in School Lane (formerly Poor House Lane). Commons Lane refers to the common land which originally belonged to the parish of St Nicholas and was worked under the feudal system.

The houses round The Green were built *c.* 1850, though some of the smaller houses date from about 1800. These were rebuilt or converted into their present form from fishermen's cottages.

Magnolia, Fore Street, with its intricate cast iron verandah was built about 1850 as were the houses in Marine Terrace, Clifford Place and Bridge Street.

Ness House dates from Regency times and traditionally is said to have been erected on the site of an older, larger house. Delderfield reports that the thatched building near the entrance to the tunnel in the grounds of Ness House was once a tithe barn and was given to Nell Gwynne by Charles II, but sadly there is no proof of this, although it is said that during the course of alterations some years ago her name was found on an overmantel. Ness House has been the home of many illustrious people. Early in the twentieth century it belonged to the Holders – the shipping magnates. It is believed that the Holder family built the tunnel to the beach in order to give themselves easy access. Local stories have grown up around this tunnel. It is said that the lower branch, now fallen in and sealed off, was the original working, and that this led from the beach to a farm further inland used by the smugglers. The truth may never be known. There *were* smugglers in Shaldon.

The Round House on the Esplanade was used as a fish salting and storage place until the last century. During recent renovations clear evidence was found of this. The Newfoundland industry was an important factor in the lives of the people of Shaldon. Many ship owners settled there and the village grew rapidly in the eighteenth and nineteenth centuries, but men had been sailing to the Grand Banks a long while before that.

It is said that when Southwood Cottage was repaired some years ago a packet of papers was found in the attic bearing dates in the seventeenth century. One referred to the burial of the wife of John Birkford and is dated 1675. Another, dated 1769, is a copy of the will of another John Birkford in which he leaves his relatives books, pitchforks, a silver watch, barrels and a gold ring. There was also an exercise book belonging to a child called Rowe. On one page is scribbled 'I wish us was going home'. Some of the documents in the package were addressed to Mr Thomas Rowe, St Johns, Newfoundland.

In 1893 the village was large enough to warrant a church. Ringmore was too

A typical corner of Shaldon

small and too distant. Between 1893 and 1902 the church of St Peter was built almost on the river bank. It is constructed of red sandstone with polyphant dressings and piers. The river front facade is long and uniform, broken by the low vestry with cupola. The west window is deeply recessed under a Gothic arch. In the south aisle is an altar of Devonshire and Sicilian marble; there is also a marble altar with alabaster steps. The wagon-type roof is of stone and there are some rather unusual arcades with rusticated surrounds. In 1924/5 the church was restored at a cost of £5,500.

Lord Clifford's connection with Shaldon ended in 1949 when he sold his remaining holding to Teignmouth Urban District Council.

For some while it was in the balance whether Teignmouth or Torquay would acquire the Ness estate. In the end Teignmouth bought it and Ness House was leased out for use as a restaurant. The tunnel was restored and Ness Beach made easily accessible. Several cliff falls have occurred which made this undertaking more expensive than was originally envisaged. The Ness itself is slowly being eaten away by the sea.

A lime kiln used by the former owners of Ness House can still be seen by the entrance to the tunnel.

During World War 1 a small church was provided for Roman Catholics in Shaldon. In 1932 the Baptist Chapel was converted to its present use as a

Roman Catholic Church and dedicated to St Ignatius Loyola, founder of the Jesuit movement. The first marriage took place there in 1952.

After World War 1 William Homeyard, famous maker of Liqufruta cough mixture from an old gipsy recipe, came to live in Shaldon. He settled at Ness Cottage and bought a stretch of land which went right across the village. After his death the land on which The Hamiltons is built was given to the village, also Broadlands and Homeyards. On the death of Mrs Homeyard the Botanical Gardens, which had been made for her personal use were given to Shaldon as a public park. Mrs Homeyard had a kitchen built on the site where she could make her afternoon tea. Part of this remains.

Near the vestry door of St Peter's a stone was erected by the widow over Mr Homeyard's grave. It bears the inscription ATURFUQIL which is Liqufruta backwards.

Before the building of the bridge in 1827 cattle and horses needing to go to Exeter were driven through the Teign at low tide. If the current was fast they were roped together. On the Teignmouth side they were driven up Mill Lane and over the hills to Exeter. Even after the coming of the railway this practice continued; it was cheap – there were no bridge tolls. Because the custom was of ancient origin the railway had to make a tunnel for the beasts to cross the line. It is still there, but silted up. Locally it is called Drovers' Arch.

Shaldon School opened in 1876 – soon after the passing of the Education Act. It was built on marshland bought from Mr Brookes for £180.

Three shipbuilding yards at Ringmore, one of which was mentioned by Robert Jordan, gradually lost trade and closed down in the last century. In 1900 two remained, owned by Edward Bulley and Samuel Hook. The remains

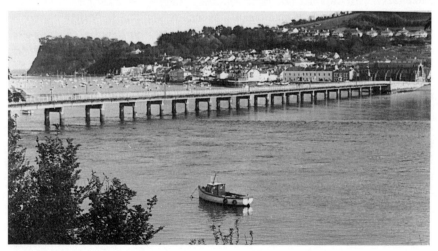

Shaldon Bridge today

of a slipway can be seen by Ringmore Towers. The Towers is a nineteenth century folly and has no antiquity.

In 1984 Shaldon achieved its own Parish Council and became independent of Teignmouth. It is now able to deal directly with Devon County Council and Teignbridge District Council. The new council consisted of seven members.

Labrador

The first known settler at Labrador was a cod trader, Captain Trapp, who built his home there about 1630. He named the place after the coast where he fished: *L'Abri d'or* – the Golden Shelter. Captain Trapp did not live long to enjoy his home: he died in 1643 and Labrador remained empty except for certain nocturnal goings-on involving contraband goods. In the later 1670s or early 80s a Frenchman, Pierre Ducress, moved into the deserted dwelling. There is no record of how he lived but local people thought him a Jacobean spy with his main interests elsewhere. After the raid on Teignmouth by the French in 1690 feeling ran so high against Ducress that he decided to move - no doubt there was a little local persuasion.

Nothing more is recorded until 1740 when a Cornish fisherman who had had some trouble in his home town moved in. He was convicted of smuggling and moved off to an unknown destination. A potato farmer lived at Labrador in 1758. He too, found a means of supplementing his income which did not meet with the approval of the authorities, but he managed to survive until about 1800. In 1815 Napoleon, on his way to Torbay, in the *Bellerophon*, was almost wrecked on the rocks which abound off the cliffs of Labrador, but disaster was averted and the emperor went to Torquay *en route* for St Helena.

In 1830, while smuggling was still being carried on, Labrador became a goat farm, but again the revenue men moved in and the place became derelict until 1850 when it was bought by a Welsh gentleman as a private residence. One of the last boats to run from Labrador was the *Goldfinch* which carried 100-120 half-ankers (each about 4 gallons) of brandy.

On the death of the Welshman his residence was converted into an inn which brewed its own ale from the local spring water. In 1909 a stock-broker bought the inn and discontinued the licence. He planted fruit trees and strawberry beds which became very popular with visitors to Shaldon and Teignmouth. The spring became a wishing well – also attractive to visitors.

After World War 2 a mail order business was carried on selling the water from the wishing well but this was discontinued after a well-known Sunday paper visited the place.

Once more Labrador Bay has become a private residence – and a palatial one at that: the lawless times are over.

Appendix II
LOCAL LEGENDS

1. The Parson and the Clerk

There are several versions of this story and for the sake of variety I would like to record one which differs from that which I used in a previous edition of this history.

The Vicar of Dawlish (he was also the Vicar of East Teignmouth) and his clerk were returning home after collecting tithes in the parish of St Michael. It was a wild, wet night and the two men were miserable. When they came across a brightly lit house from which sounds of merriment issued they decided to knock on the door and ask for shelter.

'I could do with a little warmth, couldn't you?' said the priest to his companion.

Their knocking was answered by a reveller who begged them to enter and who pressed wine upon them.

The house seemed strange. For one thing, although they knew the route well they had never seen a building in that position before; also it had a musty smell. The great hall, although well lit, had some dark corners. The drapes looked like seaweed and seemed to be damp. However the two men drank deep and soon the priest was telling stories which amazed his clerk who did not think that parsons knew about such things.

Eventually they rose to go, but were so inebriated that it was difficult to mount their horses. Their sense of direction was impaired. After a few steps they found themselves in the sea. The clerk turned back and tried to cling to the cliffs, but his horse was swept from under him by the swirling waves. He heard his master repenting of his sins, commending himself to God. The clerk tried to pray.

The next day the people of Teignmouth were amazed to see that the night's storm had given them two new rocks. There they stand to this day - the Parson and the Clerk.

2. The Poachers' Rebuke

At the end of the last century a couple of stout-hearted local lads, returning from a poaching expedition in the vicinity of Kenton, intended to reach Teignmouth by way of Smugglers' Lane and the sea wall. It was a deserted area where they could not encounter any police.

The night was dark and the wind prowled eerily through the bushes. In Smugglers' Cove they skipped up the steps, only too glad to leave the slippery, weed-covered rocks and the sucking black water beneath. As they climbed they became conscious of a Presence waiting on the wall above. It was

a very tall man – taller by far than any ordinary mortal – clad in black. His eyes burned like twin coals. Beside him crouched two huge black dogs, their tongues red and lolling. The group seemed to be enveloped in a cold mist.

The lads, being Devonians, had no doubt about what they were seeing. It was the Devil waiting to claim their souls which they had jeopardized by their misdeeds.

They did not stop to argue, but fled back down the steps and up Smugglers' Lane as fast as they could go.

The next morning a visitor walking the sea-wall was surprised to find a sack of venison and a brace of pheasants.

It is said that young men never went poaching again, but devoted themselves to good works.

3. The Treasure of Lidwell
In the fourteenth century travellers on the way to South Devon often passed the night at the Chapel of St Mary on Haldon. A hermit monk, Robert de Middlecote welcomed them. During the night the monk robbed and killed his charges, throwing their bodies down the well in the corner of the chapel.

A sailor who suspected the monk's intentions pretended to be asleep but in reality was very much awake. When the monk bent over him he struck out and de Middelcote was killed. (This is historically inaccurate since Robert was hauled before the Bishop of Exeter and was executed for his sins on 17 May 1329).

It is said that de Middlecote's ghost keeps watch over his plunder which still lies hidden in the well. Only a young man pure in body and soul, who climbs down the well at midnight on Midsummer Eve, can recover the treasure. So far the cáche is safe.

On dark and stormy nights the spirits of women and children killed by the monk can be heard wailing around the chapel at Lidwell. It is also stated that R H D Barham (who, if the story is true, really should have known better) said that anything dropped into the well would slip under the Teign (some 700 feet below and a mile or so away) and continue underground to emerge at Kent's Cavern in Torquay. Perhaps the treasure should be sought there.

4. The Buckeridge Horsemen
Hints appear in various early manuscripts that the Buckeridge area of Teignmouth is haunted. The late Mr R W Waterfield who lived at 7 Buckeridge Road made notes about 'the unholy things that ride at night along Buckeridge Road.'

The ridge – in fact it corresponds more closely to Exeter Road – connects Haldon with the sea and was an ancient trackway used for the collection of salt. The lowland Saxons were probably on bad terms with the Celts whom

141

they had displaced and the legend may be a dim memory of warfare between the two races.

5. The Devil's Hoof-Prints

This well-corroborated phenomenon occurred during the night of 8 February, 1855. Heavy snow had fallen over South Devon, and in the morning country folk found a line of hoof-prints going in single file from the east side of the estuary of the Exe, through Starcross, Mamhead and Dawlish, through Teignmouth and on to Totnes. The prints were in all sorts of unlikely places such as the tops of walls and the roofs of houses. They were sharply defined as 'if branded with a hot iron.'

A number of experts who examined them at the time were unable to agree what kind of animal had made them. No satisfactory explanation of the matter has ever been given.

A reader writing to the *Illustrated London News* said that 'no known animal could have traversed this extent of country in one night, besides having to cross estuary of the sea two miles broad. Neither does any animal walk in a line of single footsteps not even man.'

Since the prints were those of a cloven hoof there was no doubt in the minds of local people. The Devil had visited South Devon.

6. The Figure on the Bridge

A few years ago a bundle of clothes was found on Shaldon Bridge, and though no body was ever found, it was believed that the owner had committed suicide by jumping into the river. Several respected local residents insist that they had seen a tall and ghostly figure, clad in mist, leaning over the rails.

Appendix III
NAMES AND DERIVATIONS

Ashleigh
after Ashleigh House, demolished 1956.

Bank Street
after the bank which formerly stood on the site of Woolworth's Stores.

Bitton
after Bishop Bytton, fifteenth century Bishop of Exeter, who used Bitton Manor as a summer retreat. Nos. 3-8 Bitton Park Road were built about 1837 and originally known as Victoria Place.

Boscawen Place
after General Boscawen who lived nearby in the last century.

Brimley
a flood meadow.

Brook Hill
from the bottom of Shute Hill past the station yard to the beginning of French Street. The Brook - the Tame - flowed across the lower part.

Brunswick Street
a compliment to Caroline of Brunwick, wife of George IV. Their only child, Charlotte, died in 1817. The street dates from about this time.

Buckeridge Road
formerly Bugridge Road. A place to be shunned (bugger ridge). Locally believed to be haunted.

Cartwright Crescent
after the Cartwright family, especially Miss Kate Anson Cartwright, twentieth century County Councillor and Chairman of Teignmouth Urban District Council.

Chapel Street
now demolished. Ran parallel to Bitton Park Road off Saxe Street. There was a Primitive Methodist Chapel there, later Wesleyan.

Clampit Lane
follows the line of an ancient track running from St Michael's Church across the Long Bridge, through the present lane – blocked at the Lower Brook Street end by Tapley Cottage and divided in two by Orchard Gardens – continuing through Commercial Road (now demolished) through Stanley Street to the estuary of the Tame. The track followed the right hand bank of the stream. The name indicates a storage place for shellfish.

Coleman Avenue
after the Coleman family benefactors of the town, and Mr H Coleman, Chairman Teignmouth Urban Distrcict Council.

Commercial Road, now demolished
Ran from the bottom of Saxe Street to Fore Street. The Royal Oak Inn stood there.

Daimond's Lane
after Daimond who lived there. Formerly Church Street. In 1825 Daimond's Plot between the Lane, Exeter Road was thick with trees. William Penson of Daimond's House bought it for £110.

Deerpark
A place where deer fed. Deer from Haldon strayed there in former times.

The Den
Saxon *don*, a dune, down or hill. Note a 'down' is an upland.

Donkey Lane
see Scown's Lane

Ferndale Road
formerly Lower Bugridge Lane

Fore Street
largely demolished. Ran from end of Exeter Street to the London Hotel. The upper end passes over part of the graveyard of St James', which was cut back to allow better access to Bitton Park Road. The street is shown on a map of 1805, but not on one of 1759.

French Street
built by public subscription after the French raid of 1690.

Gale's Hill
after Gale, a nineteenth century tailor, who had a shop there.

George Street
compliment to one of the many Georges – kings of that name. Built about the time of George IV.

Haldon
Origin unknown. King Huwell or Howell fought there against the Saxons in 927, was defeated and slain. Perhaps he is buried there – Huwell's Hill.

Higher Brimley
Cut out of the hillside above Brimley Brook. *See* Brimley.

Higher Brook Street
demolished to make way for the dual carriageway. Formerly from Fore Street to Brook Hill. The Prince of Wales Inn stood on the upper corner in Fore Street.

Holland's Road
formerly Holland's Row. Built by Holland a local banker.

Hutching's Way
after Thomas William Hutchings, first Chairman of Teignmouth Urban District Council.

Jordan Drive
after the Jordan family *qv*.

Lake Avenue
after the nineteenth century Lake family.

Landscore Road
follows a boundary made by a furrow (a landscore). Up till 1914 there was a pound for stray animals at the eastern end.

Larry, The
Local name for heavy mist which sometimes hangs low over the River Teign. From Middle English *lah* meaning low.

Market Street
now called Teign Street. The market was formerly there.

Mary Heath's Lane
see Queen Street.

Milford Close
after Mr Milford who lived nearby and gave Milford Park to the town.

Mill Lane
the mill stood at its lower end.

Mulberry Street
now mainly demolished, although part remains below the Bitton Park Road flats. Built early seventeenth century. It ran from Bitton Park Road to the Tame, crossing the non-existent Teign Street and continuing down Scown's Lane.

Myrtle Hill
Nineteenth century Teignmouth was noted for its fine myrtles.

New Road
built at the end of the nineteenth century to link Exeter Road and Dawlish Road.

Orchard Gardens, Teignmouth, today

146

Orchard Gardens
built 1870s on the grounds of Orchard House, although the area was so named much earlier and there was some sort of thoroughfare.

Osmond's Lane
possibly the most ancient trackway in Teignmouth. It followed the left bank of the Tame, on the line of the old salt works, to the Teign. Now divided by Northumberland Place.

Paradise Road
formerly Paradise Lane. Fifty yards of the original lane remain between Paradise Road and Ferndale Road.

Park Street
now demolished. Ran from Saxe Street to Fore Street with a pound for stray animals at the lower end.

Parson Street
the curate of St James lived here. The street connected Bitton Park Road with the estuary of the Tame. An old street parallel to Bitton Park Road connecting Parson Street, Mulberry Street and Saxe Street has been demolished. It ante-dated Bitton Road.

Pennyacre Road
land was worthless, 1d per acre. Otherwise *pen* (headland) in *ager* (field).

Polly's Steps
Pellew's steps – from Bitton House to the Teign.

Queen Street
formerly Mary Heath's Lane. Mary plied a daily boat to Newton Abbot. The name changed on the accession of Queen Victoria.

Rat Island
no doubt infested with vermin. An island at the mouth of the Tame reached by a bridge. It lay between Somerset Place and Osmond's Lane. Site of the Jolly Sailor Inn and an earlier ferry crossing.

Regent Street
built during the regency of George IV.

The Ropewalks
when ropes were handmade – by women – from hemp grown in their gardens, a straight lane was necessary for the twisting of the fibres. There were ropewalks in Thorniley Drive and parallel to Barnpark Road.

Salisbury Terrace
after nineteenth century statesman of that name.

Saxe Street
now demolished. Ran from opposite St James' Church to the Tame, crossing non-existent Teign Street and continuing down Sun Lane. The oldest Street in Teignmouth. Three old cob cottages which stood at the top were demolished 1969. Douglas House stands on top right corner. Renamed for the Saxe-Coburg family.

Scown's Lane
after early twentieth century building firm of that name. Formerly Donkey Lane. Donkeys were stabled at the lower end. The Lane ends roughly where there was a small harbour used by local fishermen. Here they sat to gossip and mend nets, at the mouth of the Tame. Some of the original cobbled paving of the Lane remains at the Teign Street end.

Shaldon
seventeenth century Shaldown. Could be Shell hill.

Shute Hill
from Devonian 'shute', a fast torrent. The Winterbourne stream poured down Heywood's Road into the Tame.

Somerset Place
after the Duke of Somerset who stayed there for a while.

Stanley Street
after nineteenth century explorer. Formerly called Furze Lane.

Sun Lane
The Sun public house stood on corner at 39 Teign Street. Formerly called Globe Lane after the Globe Tavern which stood on the site of present Unionist Club. An old warehouse still stands near the bottom end.

Stanley Street, Teignmouth, today; one of the few old streets which remains. The eighteenth century central gutter, filled in, is clearly visible

Teignmouth
Anglo-Saxon Chronicle refers to Teinewic (pronounced Teenawick). Camden mentions *Tinemutha*. Could be from Welsh (Celtic) *taen*, meaning a shower of water, but *isc*, *exe* or *axe* are the usual Celtic for water in Devon. Might be simply the tin river (from the mineral workings upstream).

Venn
Devonian for fen or marsh.

Victoria Place
see Bitton Park Road

Waterloo Street
after the victory of 1815

Wellington Street
after the victor of Waterloo

149

Willey Lane
formerly Welly Lane or Wella Lane. Now demolished. Ran parallel to Bitton Park Road, opposite St James's Church off Saxe Street.

Yannon
formerly Hennon.

Authorities consulted

Anglo-Saxon Chronicles: Heinemann, 1983
Berlioz, H: *Extracts from Journal des Debats*
Blair, P H: *Introduction to Anglo-Saxon England,* 1959
Bulley, J: *Teignmouth in History,* 1958
Burnet, G: *History of His Own Times,* 1823
Burney, Fanny: *Early Diaries,* 1778
Camden, W: *Britannia,* 1607
Carrington, N: *Teignmouth, Dawlish and Torquay Guide,* 1820
Chadwick, N: *The Celts,* 1970
Chapple, W: *A Review of Risdon's Survey,* 1788
Clark, E A: *Ports of the Exe Estuary 1660-1860,* 1960
Cleland, W: *Notes on the History of Bishopsteignton,* 1938
Coleshill, T: *Revenue List,* 1549
Cresswell, B: *Notes on Devon Churches: the Deanery of Kenn,* 1900
Cresswell, B: *Teignmouth,* 1901
Croydon's Guides to Teignmouth: 1817, 1820
Culliford, W: *Report 1682/83* (on smuggling)
Delderfield, E R: *Torbay Story,* 1951
Devonshire Association Transactions: Vols 11,31,32,36,75,78,81,88
Dunsford, M: *Miscellaneous Observations in the Course of Two Tours through the West of England,* 1800
Ewans, M C: *Haytor Granite Railway and the Stover Canal,* 1966 *Exeter Flying Post*
Exeter Port Books
Exeter Custom House Register of British Ships
Fursdon, J: *Devon Parishes,* 1927
Hartley D & Elliott, M: *Life and Work of the People of England: The Middle Ages,* 1931
Hay, D: *Westcountry from the Sea,* 1960
Hoskins, W D: *Devon,*
Hudson, D: *A Poet in Parliament,* 1936
Hunt, P ed.: *Devon's Age of Elegance,* 1984
Innis, H A: *Cod Fisheries,* 1940

Jordan, R: *Letterbook 1795-1800*
Keats, J: *Letters*, ed. Forman, M, 1935
Lake, W M: *History of Teignmouth*, 1870
Lamb, C: *Miscellaneous Writings in Prose and Verse*, 1818
Layamon, Brut: *A History of the English*, 1847
Leland, J: *Itinerary 1534-43* (pub. 1710)
Lysons, The: *Magna Britannia*, 1822
Macaulay, T B: *History of England*, 1849
Maton, W G: *Early Tours in Devon and Cornwall*, 1790
Oppenheim, M: *Nautical History of Devon*, 1968
Parry, H: *Notes on Old Teignmouth*, 1912
Pevsner, N: *South Devon*, 1952
Pigot's Directory, 1823
Pole, Sir W: *Collections towards a description of the County of Devon*, 1620
Polwhele, R: *History of Devon*, 1797
Risdon, T: *Choreographical Description of the County of Devon*, 1630
Shaldon Jubilee Salute, 1978
Stephens, W B: *West Country Ports and the Struggle for the Newfoundland Fisheries in the 17th Century*, 1951
Stow, J: *Annales*, 1605
Teignmouth Post and Gazette (files)
Thornton, W H: *Reminiscences*, 1899
Trump, H J: *Teignmouth*, 1986
Wace, *Roman de Brut*, *1154* (Madden 1847)
Walker, N: *Short History of Bishopsteignton*, 1960
Westcote, T: *A View of Devon*, 1635
Western Morning News, 1900, 1910
White's History and Gazeteer of the County of Devon, 1850
Willan, T S: *English Coasting Trade 1600-1756*, 1938
Woolmer's Exeter and Plymouth Gazette

INDEX

Bold type indicates illustration

INDEX

INDEX

INDEX

More books from **Ex Libris Press** *are described below:*

TALL SHIPS IN TORBAY
A brief maritime history of Torquay, Paignton and Brixham
John Pike

'Torbay's maritime story is far more fascinating than many might suppose. A book of lasting worth and, characteristically, splendidly researched and written.' *(Western Morning News)*
144 pages Numerous engravings and photographs Price £3.95

IRON HORSE TO THE SEA
Railways in South Devon
John Pike

'John Pike is a careful and painstaking historian, and his survey of the railways of South Devon deserves the widest readership.' *(From the Foreword by Crispin Gill)*
160 pages Map; numerous photographs and engravings Price £3.95

BETWIXT MOOR AND SEA
Rambles in South Devon
Roger Jones

'Walkers following the routes described will be taken into a quiet and still largely unspoilt corner of the county ... A lengthy introduction sets the scene, dealing with geology, people in the landscape and place names ... none of the routes are over-strenuous and most are well waymarked.' *(The Great Outdoors)*
96 pages 16 maps; drawings Price £2.95

A BOOK OF NEWTON ABBOT
Roger Jones

'This book must be assured of a permanent place in any bookshelf or library as a continual source of pleasure and of reference for future use.' *(DevonLife)*
152 pages Map; numerous illustrations Third edition 1986 Price £3.95

Ex Libris Press books may be obtained through your local bookshop or direct from the publisher, post-free on receipt of net price, at 1 The Shambles, Bradford on Avon, Wiltshire, BA15 1JS.
Please ask for a free copy of our complete catalogue of West Country titles.